PENNSYLVANIA SCRAPPLE

A Delectable History

AMY STRAUSS

AMERICAN PALATE

Published by American Palate
A Division of The History Press
Charleston, SC
www.historypress.net

Copyright © 2017 by Amy Strauss
All rights reserved

First published 2017

Manufactured in the United States

ISBN 9781625858856

Library of Congress Control Number: 2017944971

Notice: The information in this book is true and complete to the best of our knowledge. It is offered without guarantee on the part of the author or The History Press. The author and The History Press disclaim all liability in connection with the use of this book.

All rights reserved. No part of this book may be reproduced or transmitted in any form whatsoever without prior written permission from the publisher except in the case of brief quotations embodied in critical articles and reviews.

For my mom and dad, Claudia and Mark Strauss, who raised me as a true Pennsylvania Dutch girl, with endless plates of crispy scrapple, soul-warming hogmaw and just-fried fastnachts.

To Terry Schwenk, who was—and always will be—the king of scrapple.

CONTENTS

Acknowledgements	7
Introduction	9
Scrapple 101: Meet the Underappreciated King of Breakfast	13
Blast from Pennsylvania's Past: How the German Settlers Invented "Pan Rabbit"	22
Heavyweight Champs: Habbersett and Rapa Scrapple	33
In Celebration of Meat: Uncovering East Coast Scrapple Festivals	45
On the Farm: Generations of Families Continue Scrapple-Making Traditions	54
Behind the Butcher's Doors: Talking Scrapple-Making with Small-Town Butcher Shops	63
Whole-Animal Butchery Made Scrapple *New* Again	70
What's for Breakfast: How to Eat and Prepare Scrapple	78
Short Order: Classic Restaurants Make Scrapple a Permanent Staple	83
How Scrapple Became Trendy	92
You Did *What* with Scrapple?	97
Appendix I. Get in the Kitchen: Scrapple Recipes to Spark a Meaty Love Affair	111
Appendix II. Your Philadelphia Scrapple Guide Book	117
Bibliography	121
Index	125
About the Author	128

ACKNOWLEDGEMENTS

There is something humorous yet incredibly serendipitous that I dedicated months of my thirtysomething life to building a sometimes unexplainable narrative for the "meatloaf" of breakfast, scrapple.

It brings me so much joy to be able to share with my Pennsylvania Dutch–bred family and my friends sprinkled through the Mid-Atlantic region that I penned a book on scrapple. I owe endless gratitude to The History Press for seeing in me the fire that feeds my scrapple-loving soul, so much so that it granted me this opportunity to share with you all the historical secrets I could scrape up on the porky delight. To Karmen Cook, I thank you for scanning the wild world of Twitter to scout me out for such a significant opportunity, and to Banks Smither, for being a terrifically cool, knowledgeable editor to guide me through this journey. Endless appreciation and applause is due to Ryan Finn, a true editing professional, who helped finesse and refine this delicious piece of work into what it is today. Most importantly, to Mat Falco (my rock, a real-deal all-star!), my sweet brothers (Joel and Jimmy Strauss), Rachael Schwenk and the Lady Gang (Audrey and Rachel Bauer, Jenna Butkovsky, Danelle Ferguson), I extend my heartfelt gratitude to each of you for your never-ending encouragement as I blindly worked my way through my first book.

To every butcher, manufacturer, chef and advocate who allowed me the time to enter their scrapple worlds, share their stories and humor my never-ending excitement for the subject matter, I thank you. Much appreciation is also due to every single man and woman who continues to

Acknowledgements

work incredibly hard and through endless hours to produce scrapple so we can carry on our delicious obsessions with the darling meat slabs.

And to you—you must love scrapple, right? I mean, you are reading this book. God bless you!

INTRODUCTION

There are two types of people in this world: those who like scrapple and those who don't. Scrapple naysayers must be warned. When you try with an open mind a properly prepared slice of the down-home staple, your palate will undergo a euphoric textural playground unlike anything else experienced in the world of meat.

It's not quite sausage. Or bacon and pork belly. It's nowhere near Spam. It's basically the Carrot Top of meat products. Its ragtag medley of ingredients have long been a heated debate; they're the most-talked-about-but-never-understood kid on the mystery meat block.

Scrapple is to Philadelphia what the crab cake is to Baltimore, the po'boy is to New Orleans, the toasted ravioli is to St. Louis or the less-cool pork roll is to southern New Jersey. Through rose-colored glasses, or in simplest of terms, scrapple is mostly ground pork. Throw it in a frying pan until it reaches the crispest exterior shell and soon you'll unmask a creamy, melt-in-your-mouth interior that's just dying to meet your taste buds' acquaintance. It is a Pennsylvania Dutch classic. It is the breakfast of pork-loving champions, a piece of my heritage that so many don't understand. But I do, and boy do I have a story to tell you.

Scrapple has come a long way since its farm roots. It was the result of thriftiness and love of good eating that categorized the early German settlers. Sure, some still will carry on the tradition of making it in large vats on cold winter days for the family. But since the late 1800s, it has slowly transitioned into a mass-produced product, millions of pounds

Introduction

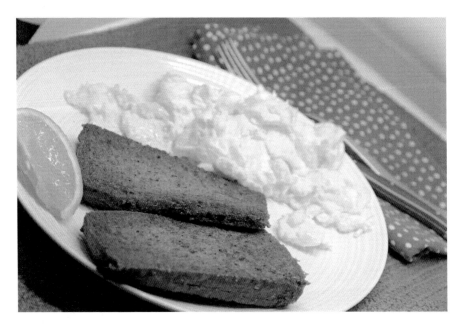

A classic scrapple breakfast with scrambled eggs. *Amy Strauss.*

stacked like bricks in your local supermarket. The competition is fierce and the consumers are opinionated, but it's certain there's a demand for the "crudest of all pork products."

Unlike the poultry industry, which evolved and affected the agricultural climate and economy, scrapple has survived as a niche business on the East Coast. Its production process has changed little since its days of old-fashioned hog killings on farmlands, and the family recipes remain intact, even when marketed under household names like Habbersett and Rapa.

Still, in 2017, scrapple is commonly known and eaten in the Mid-Atlantic region, most popularly in Pennsylvania and Delaware. It's strictly my Pennsylvania crowd that demands it, along with the Pennsylvania expats who have traveled to the coasts and longed for its taste. Even swashbuckler W.C. Fields, who originated from Philadelphia, had scrapple shipped to his Hollywood home as long as he lived. Cultural legend states that George Washington possessed "fondness for scrapple that lasted a lifetime" and had a Pennsylvania Dutch cook at his encampment in Valley Forge. And good ol' Benjamin Franklin was also known to have a dear affection for it.

Praise be given to people like writer Frederick C. Othman, who after his first genuine taste of the Philadelphia classic in 1955 felt the need to

Introduction

blast his positive experience in the local newspaper. "Made a new man of me; you feel like you'll never be hungry again," he wrote, "while doffing my hat to old-time Philadelphians who invented this." It's time I joined him in via written word with his scrapple-praising pursuits. It's time we gave scrapple some respect!

Scrapple is a narrative for our country that includes an early chapter set in colonial times. Once an economy dish for German immigrants, the clever, captivating amalgam of ground pork and cornmeal that established the meat-starch union has been tested through time and stays true to its original composition and recipe.

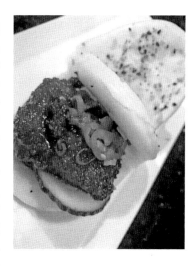

Duck Scrapple Bao Buns (with maple teriyaki, cucumber and chili) at Double Knot, Philadelphia. *Amy Strauss.*

Although created during lean times, this meal-and-meat slab of pork scraps (hence its name) has a cult foodie following. It has hosted the ability to attract low- and high-end chefs to get creative with it. There are even clever entrepreneurs making use of scrapple in off-the-wall ways you don't even eat (more on that later).

Scrapple isn't going anywhere, so be prepared. More than ever before, it is cropping up in classic and trendy breakfast dishes, available in independent and chain supermarkets, produced by local farms or small-town butcher shops and has earned permanent spots in restaurants and diners.

This book pushed me to appreciate scrapple more than ever before—and I've always been its biggest fan. But through the course of this book's research and nearly fifty-some crispy slabs later, I could not be prouder to be a Pennsylvania Dutch girl who is eager to sway even the non–meat eaters onto the scrapple bandwagon.

So, heat up your frying pans, throw in your scrapple slices and become mesmerized by the sizzle. You're about to embark on a scrapple journey through time—meat sweats included. It's time you understood the other meatloaf.

SCRAPPLE 101

Meet the Underappreciated King of Breakfast

I was destined to have a piece of a scrapple slapped across my plate. Born in Barto, Pennsylvania, a "village" or "unincorporated community" of Berks County, I lived a country life where you were built to appreciate tasks like going to the local farm for raw milk or helping to raise animals that you, in turn, butcher to live off for months on end.

I attribute much of my scrapple appreciation to my father, who also grew up nestled within the rolling, tree-speckled hills of Barto. I'd be snuggled away in my childhood bedroom and could hear his griddle sizzling through the walls, wafts of meaty delight spilling into dreams and pinging me to start my day strong. He'd be whipping up his share of morning meatloaf because he genuinely loved the taste—it's "really good," he'd say—and appreciated its ability to be a cheap, day-filling protein that was a no-brainer to keep stocked 365 days of the year.

It was common for us, on Saturday mornings, to go for a drive a few quick miles to the local small-town butcher shop—then Brook's, now Burt's—to load up on meat for the week. Plastic-wrapped hunks of scrapple were stacked in the corner of the butcher's case, always on hand. It was as if the bricks of the "everything but the oink" meat were animated, beckoning us to allow it to meet its match—the cast-iron skillet, of course.

We lived in a community rich with the Pennsylvania Dutch. Our biggest town nearby was Boyertown, home to roughly four thousand citizens, a sizable high school that played decent football and plenty of mom and pop restaurants.

Pennsylvania Scrapple

Country scrapple at its finest, straight off the flat-top. *Amy Strauss.*

Our ancestors spawned from the first settlers of eastern Pennsylvania, who came from the Palatinate in Germany in the early eighteenth century. We brought scrapple to America. We supported its rise in popularity and maintained its existence into present day. We have scrapple in our blood—or perhaps deep in our clogged arteries.

So, when I left my hometown to sow my oats and expand my culinary horizons, reality slapped me across my hungry face. The beloved, extra-crispy slabs of scrapple were only a regional delicacy that those born and raised in the Mid-Atlantic region had an affection toward. My naïve bubble had been burst, uncovering that I could no longer savor a hearty slice of the other meatloaf at any of the neighborhood restaurants that were at hand.

Scrapple is truly the world's most underappreciated breakfast meat. Pennsylvania itself was built for scrapple lovers—the state is even in the shape of it. Comparable in structure to liver mush or Spam, the polarizing pork product was invented during colonial times and was the marriage of old-world sausage-making and new-world corn. It was a humble dish made with thrift in mind. Loving scrapple means loving pork.

If you're scratching your head and wondering how something that has the word *crap* baked into the middle of it could be the secret weapon to

starting your morning off on the right foot, trust me, it is, and you have a lot to learn. Scrapple isn't just a pork dish made from boiling all the pig's "nasty bits" to eventually create a loaf of meat. It's a testament to a way of life that's not forgotten, where you'd be resourceful with the animals you had raised. After a day of butchering on the farm, nothing was left over and "everything but the oink" would never go to waste. Scrapple was an excuse to make use of every part of the pig you'd usually discard.

In simplest terms, butchering scraps would extend to months of breakfast meat—boiled, ground and combined with cornmeal, buckwheat and common seasonings, like sage and coriander, to produce breakfast meat for months. It was a way of life, a way of frugal living and an easy answer to feeding families, especially those exceeding more than ten family members.

So, why is it misunderstood? Nothing foreign or artificial makes its way into a scrapple batch. You can trust that when slicing into a crunchy surface of the enigmatic meat, you are eating mostly pork. It's a cornmeal porridge infused with rich, piggy goodness.

Take, for example, one of the most notorious, mass-produced scrapple brands: Habbersett Scrapple. Its ingredient statement is simple, spouting off the following: pork stock, pork, pork skins, cornmeal, wheat flour,

Hunk of scrapple being sliced to fry up for breakfast. *Amy Strauss.*

pork hearts, pork livers, pork tongues, salt and spices. These are natural ingredients a consumer would understand going into the final product. Nothing is masked—it's completely transparent. It's whole food. It's real food. It's nothing to be afraid of—unless you're a vegan, in which case it's probably time to read a new book.

Scrapple, though, in all its scrappy glory, has had its fair of share of ups and downs in the limelight. Some folks would argue that the words *delicious* and *scrapple* do not even belong in the same sentence. Others have a skewed perception of the Pennsylvania Dutch staple, thinking that "everything but the oink" means pig's feet, bones, brains and, heck, maybe its tail as well.

But people like me have made it their mission of advocating that scrapple isn't as rough-around-the-edges as you might think. Take, for example, "EPICURE," a New York City–based, scrapple-eating machine of 145 years ago. In January 1872, he invaded the letters page of the *New York Times* with his poetic celebration of a mysterious Pennsylvanian meat. Identified as EPICURE, he penned an editorial titled "How to Reduce Household Expense" and slipped it in the mail, hoping to catch the eye of the *NYT* editor. In his glorified write-up, he praised scrapple as being "toothsome" and "a delicious article of diet at a very small cost, which takes place of meat at the morning meal."

Although limited in his word count, the passionate scribe relayed that after moving to New York from Pennsylvania, he missed his dear scrapple. As a consequence, he and his wife spent a great deal of money on mutton chops and beefsteaks to eat for breakfast instead. To shed costs, his wife brushed up her "cookery lore" to re-create the loaf that held much sentiment to them both. EPICURE boldly concluded his letter with the suggestion that if anyone who may read his letter would be intrigued to acquaint their palates with his fine morning meat, he'd be happy to get the exact proportions of the recipe from his wife.

Epicure's letter to the editor of the *New York Times* that sparked the Great Scrapple Correspondence of 1872. *Excerpt from* New York Times.

A Delectable History

A few days later, after seemingly a flood of reader requests, the *New York Times* ran the scrapple recipe from Epicure's "Good Lady of the House." The gentleman prompted readers to note that he was enjoying his Good Lady's scrapple as she furnished the recipe for publishing. He also gave a word of warning: "I beg to add, that whoever tries the recipe will not get discouraged if they should not succeed on the first attempt, as a great deal depends on having the right proportions of the ingredients, and in the article, being fried very brown and crisp."

The recipe was thorough in preparation but limited in ingredient specifications. It was written as if your own grandmother spouted off a recipe she knew by heart. It included an instructional that took little time for pleasantries, such as you should "get a pig's head (fresh) weighing five or six pounds, which can be bought for twenty-five or thirty cents." She recommended a "country preferred" pig and encouraged you to "get your butcher to take out the eyes and teeth when you buy it."

She followed the standard process: putting the pork in boiling water until the bones could be separated from the meat. The tender pork would then be chopped fine and reunited with the pork broth. Seasonings would be added—"pepper, salt, thyme, sage and sweet marjoram," but not "too much herbs." Last, equal parts cornmeal and buckwheat would be stirred into the compound until it resembled a porridge.

The Good Lady was sure to take advantage of her time in the newsprint, although she was kind enough to apologize for "trespassing too much of the valuable space." She advised that the scrapple would cost fifty cents overall, and with that batch, a family of five adults would have plenty of breakfast every day for a week.

The Good Lady of the House's recipe for scrapple, as published in the *New York Times* in 1872 in response to her husband Epicure's letter to the editor. *Excerpt from* New York Times.

Then it got juicy. Weeks following, the letters column was hijacked by more than a dozen submissions, all of which were responding to the scrapple publishing. You could call it the "Great Scrapple Correspondence of 1872." Contributors with clever pseudonyms sounded off about what to do and not to do with their newly created loaves or how disgraceful talking about a poor man's meat was; weirdly, some went on rants that seemed to have little to do at all with our favorite meat. The steady influx of responses to a short letter to an editor shocked the *NYT* staff. It was a heated online message board before its time; it was a fiery comment section before the keyboard-clacking millennial era.

Submissions ranged from "Porcupine" warning readers against over-frying the scrapple to "Housekeeper" swapping Graham flour into recipe, "Middletown" revealing her method for removing excess grease and "Physician," who was obviously smitten, calling it "a positive luxury, throwing the Frenchman's pâté de foie gras entirely into the shade."

Physician went on to digress that the "best scrapple is made by farmers, who bring it to Philadelphia to sell two days of each week." He cast shame on anyone who has a distaste for the morning meal, "especially those who fill their stomachs with unwholesome dishes fried in hog's lard, which is the worst form of an 'unclean animal.'"

Like with anything, naysayers came out in droves, too, such as "Blue Bonnet." She felt so inclined to suggest to the public a substitute for scrapple: oatmeal porridge. "For cheapness and simplicity, it is far ahead of the abominable mixture scrapple, and there is no danger of an attack of trichina after having partaken of it."

But "H.G.'s" suggestion was more catered to elevating scrapple versus making it something it was not. He encouraged folks to add liver to their scrapple recipe, which would make it "immeasurably improved." He also took his time in the black-and-white to suggest that another reader, coined "Good Liver," "ought to be boiled and chopped up for giving his opinion so confidently on what he knows nothing about."

After five straight days of scrapple letters in print, a darkly humorous character, "Anti-Scrapple," contributed a gruesome tirade that, I presume, made every newspaper subscriber uncomfortable:

> *To the Editor of the* New York Times:
> *Let a few of your economists try the following recipe and they will find it is all it is cracked up to be: Take a calf's left hind leg and let it hang until it will just stay hung without falling, then take it down, after cutting the*

> **More About "Scrapple."**
> *To the Editor of the New-York Times:*
> Your correspondent "Epicure" has done well to call the attention of your readers to the article of food known as scrapple. I regard it as a positive luxury, throwing the Frenchman's *paté de foie gras* entirely into the shade. I know of nothing more tempting to the palate at the breakfast table, especially to those who have become wearied of the eternal round of steak, chop, and the rest of a long chapter. You may eat heartily of it at breakfast, and yet it does not seem to interfere with your appetite for a good dinner at 1 or 2 o'clock. It is a Pennsylvania dish, originating among the Germans, and is to be met with in Philadelphia in private families, but not in the hotels or restaurants. The best scrapple is made by the farmers, who bring it to the Philadelphia market two days of each week. Some people may object to scrapple because it contains pork, and yet they will fill their stomachs with unwholesome dishes fried in hog's lard, which is the worst form of the " unclean animal." The use of lard in cooking is an American peculiarity, and is doing much injury to our American stomachs, causing more dyspepsia than will ever be cured by the nostrums of the quacks, or the drugs of the physicians. Give me scrapple every morning for breakfast, in the season of it, and I care not who may have the steak, and chop, and sausage. **PHYSICIAN.**

> **Household Economy.**
> *To the Editor of the New-York Times:*
> I would suggest as a substitute for "Scrapple," a very nutritious, cheap and palatable dish for breakfast, " Oat-meal Porridge," the staple dish of Scotland, which has turned out so many eminent men. For cheapness and simplicity it is far ahead of that abominable mixture Scrapple, and there is no danger of an attack of trichina after having partaken of it.
> **BLUE BONNET.**
> NEW-YORK, Monday, Jan. 29, 1872.

Above: A contribution to the *New York Times*'s Great Scrapple Correspondence of 1872 by Blue Bonnet, recommending for folks to eat oatmeal porridge instead of scrapple. *Excerpt from* New York Times.

Left: Physician's response to Epicure's letter to the editor of the *New York Times* applauding him for bringing attention to scrapple as whole. *Excerpt from* New York Times.

bone out chop the meat into pieces about the size of a walnut, put them on the roof in a rainstorm for twenty-four hours, after which (if a cat don't get them) boil with a pound of licorice-root, let the lot gently simmer for a few minutes and then add a paper of Lorillard's century tobacco with a little old rye whisky, and you will have the meanest mess under the sun except scrapple.

Thus, the Great Scrapple Correspondence came to an end, and scrapple continued to fuel East Coast natives' love and hate with incomparable passion for decades to come.

Surprisingly, no other *NYT* letters sparked such fiery response for scrapple since 1872. However, I must give credit where it is due to Jan Breslow, MD, who in 1996 was acting president of the American Heart Association. She penned a lighthearted though informative pro-scrapple response to writer Russell Baker's op-ed, "Caught with the Grease." Baker, who is not my friend, dramatized that eating scrapple, especially on top of eggs and bacon, would send you flailing off in the ambulance to your deathbed. Good ol' Breslow retorted that everyone could relax and no one needed to scrap scrapple. She referenced the *Dietary Guidelines for Healthy American Adults*, which advised that it was recommended to consume less than 30 percent of one's total calories from fat, which could be applied over the course of a week. "Following this approach, Mr. Baker can eat bacon, eggs and scrapple one day but make up for this high-fat breakfast

by eating more heart-healthy foods the rest of the week," she wrote, encouraging readers to enjoy the occasional "guilty treat." It's okay to have your scrapple and eat it, too—just weave in some healthy foods.

As the popularity of food television and food blogging was on the rise, thriving especially from late 2009 to today, these platforms became the perfect stage for scrapple to earn its deserving attention. Educating viewers and readers about the "weird" pork loaf of the East Coast was all the rage. The most popular Google search linked to the "scrapple" search term has, for repeat years, continued to be "what is scrapple made of?"

In April 2012, Food Network's *Chopped*—a show that presents chefs with a basket of mystery ingredients and challenges them to prepare a winning dish in very limited time—featured scrapple as a mystery ingredient. Our pork scraps from heaven were receiving their time in the limelight. The mystery ingredient was recommended from fans of show as part of the Viewers' Choice series. (In 2012, Food Network reported that its nightly viewership was 1.3 million, so even a small percentage of that voting scrapple in is indeed a scrapple win!)

The competing chefs—Amy Johnson of New York, New York; Virginia Monaco of the Vanderbilt in Brooklyn; Ian Muntzert of the Commonwealth in San Francisco; and Ivan Dorvil of Miami—were mildly perplexed over the loaf of congealed meat, suggesting a snappy combination of disgruntled murmurs like "thanks a lot viewers" and noting that "the ingredients were put together out of a combination of sense of humor and sort of sadism."

Overall, the judges—shame on them—were not impressed with how the chefs prepared the slices of delight. The chefs' execution, perhaps tainted by never encountering the "other" meatloaf before, had minimal range from simply grilling, pan-searing and honey-crusting the scrapple.

In 2014, Zagat, a high-end food media house, trekked to Philadelphia's Reading Terminal Market to uncover what the heck is scrapple. The host, Zagat editor Molly Moker, admitted that she didn't do any research prior to filming the food segment—on purpose, to allow scrapple to speak for itself.

She kicked off her tour with rumblings such as, "okay, scrapple—a food with the word 'crap' invented right in the middle of it," "time to face my fears and find out more about this Pennsylvania delicacy" and "why are these Philadelphians eating this stuff in the first place?" Apparently taking the tongue-in-cheek approach to new levels, she paneled business owners and diners as they were forking through their crispy loaves to provide her, a naïve out-of-towner, with the answer to what the heck scrapple was anyway. The first wave of panelists didn't help in making the scrapple newbie feel

any more at ease. One spouted, "Scrapple is a pork product, and we should leave it at that," while another went right for the facts: "It's made from all the pork products you wouldn't want to put in a sausage or something else you might recognize." *Smooth.*

Yet even with endless confusion and misunderstanding spiraling around scrapple, it may be poised for a comeback. Does any foodstuff better epitomize the timeless "waste not, want not" ethos now in vogue as nose-to-tail eating? Whether in 1872 or 2017, we're committed to crawling out of the woodwork to spew our unsolicited opinions on the crunchy-wrapped, creamy causality.

Now that you know what's in it—pork scraps, pork bone broth, cornmeal, buckwheat and seasonings—let's begin. It's time to wax rhapsodic over the most notorious "mystery meat."

BLAST FROM PENNSYLVANIA'S PAST

How the German Settlers Invented "Pan Rabbit"

Scrapple is a metaphor for Philadelphia. It was invented here, going back to the 1680s, to the very beginning of this city. It hasn't changed. It still has the same ingredients today as it had 300 years ago.
—*Philadelphia historian Kenneth Finkel*

To appreciate scrapple, it is important to understand its history, how it arrived stateside in the Greater Philadelphia area and did not go anywhere. It starts with the people who invented it: the Pennsylvania Dutch.

In the latter years of the seventeenth century and the early eighteenth century, nearly all first settlers of eastern Pennsylvania came from the Palatinate in Germany. It is reported that German immigration began as early as 1682 to settle in Germantown, which is now part of Philadelphia. Most of the German settlers spread out into the wilder areas surrounding Philadelphia, transforming them into farmlands of unsurpassed bounty.

The German settlers heard of the advantages of the East Coast's irregular coastline, rich-soiled river valleys, moderate climate and good rainfall that would make new settlements of Mid-Atlantic region. They were looking for a comfortable and prosperous fresh start.

This is not to say that Pennsylvania Germans residing in the picturesque, rolling farmlands didn't encounter their share of hardships. But with considerable determination, they selected pieces of land, built homes and began to prepare and cultivate their soil.

Although this culture of people came from Germany's Lower Rhineland, they became known as the "Dutch," an Americanization of *Deutsch*—the

A Delectable History

Scrapple slices served right off the grill. *Amy Strauss.*

language spoke upon arrival. This sect of settlers developed a language, a mixture of their mother tongue from the Old World and that spoken in their new homeland, America. This language is now known as Pennsylvania Dutch. More than 300,000 native speakers remain in North America, with a large percentage of them being Amish and Old Order Mennonite.

The Pennsylvania German settlers brought the foods of their culture to the New World and, with influences from their surrounding terrain, developed new traditions. With good taste and frugal creativity, they bred what the *Philadelphia Inquirer* would, in 1890, call "Scrapple Paradise." Prior to their existence in America, you would not find the dishes of their hardier diets common among any of the earlier American settlers, like the Algonquin or Iroquois Indians. America is particularly indebted to the Germans for iconic cultural foods like doughnuts, tangy coleslaw, brown salt-encrusted pretzels and, of course, scrapple. In a 1905 essay in the *New York Sun*, Dr. David Rittenhouse Bingham rhapsodized about their invaluable contributions: "The Pennsylvania Dutch have many solid and useful qualities and one of the most engaging languages known to man; as the inventors of scrapple they have conferred upon Philadelphia and the rest of the world a priceless boon."

Pennsylvania Scrapple

In the Pennsylvania Dutch's early days in the New World, life was hard at first, with their newly acquired land yielding little to no return. Roads and towns were far apart. Necessity was the mother of invention for the Pennsylvania Dutch cooks—they had to utilize plainer food since many ingredients were impossible to source. Recipes of the past were a veritable gold mine of quality cooking and delicious possibilities set to preserve every last bit of food that they could. Enter scrapple.

Scrapple was the wedding of German sausage-making skills to American Indian cornmeal. Corn has always yielded an abundant crop in Pennsylvania—the Indians were first to fry their native product. With the Pennsylvania Dutch encountering an easily accessible corn crop, they combined their old-world sausage making with a flour made from corn—cornmeal—that they encountered in the New World. The Pennsylvania Dutch went a few steps further—they added cornmeal, buckwheat, sage, cloves and other spices, too.

The major difference between what the Germans made and what the Pennsylvania Dutch created was the elimination of pig's blood and the use of cornmeal and buckwheat. Scrapple's influences even go back to medieval times, to Holland and Northern Germany, where remnants of butchered pigs were made into a meat pudding. The Swedes, who came to Pennsylvania in the 1683, have a similar dish as well, *polsa*, which is most like Pennsylvania scrapple. It differs by making use of barley.

The evolution of how the German product developed in America blossomed out of Pennsylvania Dutch customs based on fall and winter butchering. The Pennsylvanians held a strong desire to not waste even the oft-neglected pork scraps from a day's hog slaughtering time nor waste the liquid in which meat was boiled. "The urge back of the invention [of scrapple] was the desire not to waste the nutrient contained in the liquor in which the meat had been boiled," wrote the late Marcus Bachman Lambert. "As a liquid, it could not be used, so the natural thing to do was to thicken it with flour. In the early days, the only flour available was cornmeal, hence that was used."

To make scrapple, they would allow the trimmings to be cooked in water, chopped fine and seasoned with salt, pepper, sage and other spices. Cornmeal would be added to the meat and simmering broth and cooked to a thick porridge. At this time, those who had helped with the day's butchering would be granted a steamy bowl of the porky mush to warm them as finished up the day in the winter cold.

When better milling practices became available, buckwheat was introduced into the scrapple recipe. The day's scrapple batch would be

cooled in oblong forms. It would be stored in cellars and underground throughout winter to preserve its freshness. At breakfast time, it would be brought out, sliced thin and fried in a skillet with lard. It would extend to feed large families and was capable of providing a hearty and nourishing substance to fuel a day's work on the farm.

THE UNIVERSAL PROCESS

From the tiniest bits of hog meat, unusable any way else, scrapple was born. Once the chops, the ham, the hocks, the steaks, the spare ribs and other useful cuts were taken from the pig, meat was collected from the head, heart, liver, tongue and skin. Some have been quoted saying the most nutritious scrapple contains the entire head!

No matter what leftover scraps were included, one thing was clear: scrapple made a huge impact on farm life in the eighteenth century, and it didn't hurt that it was tasty, too. "Several Anonymous Philadelphians" wrote in *Philadelphia Scrapple* this antiqued explanation full of whimsy: "For the behoof of all who may be unacquainted with the nature of scrapple, it is…a composite creation from diverse ingredients in sundry quantities. Into its mixture enter the boiled meat of the hog's head and liver; chopped and chopped into almost infinitesimal bits, abundance of powdered sage, salt and pepper…and both wheaten flour and cornmeal. Sometimes additional herbs and spices are included according to the taste and discretion of the maker."

"Discretion of the maker" was key. The secret to scrapple's success over the years was its meat-to-meal ratio. Farmers and butchers' butchering sessions would conclude with a different amount of scrap meat per session, so it was vital to ensure that balance of ingredients was front of mind. After experience with several batches under their belts, the farmer and/or butcher would develop a "special" formula to their scrapple batch's success—one that could very well become mass produced a century later.

Although exact ingredients may vary, universally Pennsylvanians agreed on the process. Once the butchering process was complete, scraps would be collected and then boiled. Heads, liver, snouts, hearts and any other edible organs and offal were often used. Once the meat was tender, it would be pulled from the boiling water, picked apart from the bones and chopped very fine or ground to later return to the pork broth to continue the process. Spices were

Pennsylvania Scrapple

> **8** *Pennsylvania Dutch Cook Book*
>
> **SCRAPPLE**
> **(Ponhaws)**
>
> Separate one hog's head into halves. Take out eyes and brains. Scrape and thoroughly clean the head. Put into large kettle, cover with 4 or 5 quarts of cold water and simmer gently for 2 to 3 hours, until meat falls from bones. Skim grease carefully from surface; remove meat, chop fine and return it to liquor. Season with one teaspoon powdered sage, salt and pepper. Sift in granulated yellow corn meal, stirring constantly until it attains the consistency of soft mush. Cool slowly for 1 hour, watching carefully as it scorches easily. When cooled pour into greased oblong tin and place in cold place. When ready to eat, cut in thin slices and fry crisp and brown.

Excerpt from the *Pennsylvania Dutch Cook Book of Fine Old Recipes*, published in 1936.

added, as was the flour, and the blended mixture was cooled into pan-like molds. It was the last product yielded from a day's butchering and also one that was able to be kept longer, as least in comparison to fresh cuts of meat.

There's an old saying—"Scrapple is only prepared during months containing the letter 'r' in their name"—that illustrated that slaughtering days were a wintertime ritual. Before refrigeration was long a food saver, pork was rarely eaten in warmer months or it would spoil. Some farmers became known as "frost butchers" because the hint of cold weather provided promise for the meat that would provide for their families. Others tended to butcher near Christmas and gave the gift of pork or scrapple as a thank-you for the day's help.

One of the oldest documented scrapple recipes to date was courtesy of Elizabeth Ellicott Lea, in her 1869 cookbook, *Domestic Cookery*. The recipe itself was basic but did its due diligence with educating "young housekeepers" for generations to come:

> *Take 8 pounds of scraps of pork that will not do for sausage. Boil it in four gallons of water. When tender, chop fine, strain the liquor and pour it back into the pot. Put in the meat, season it with sage, summer savory, salt and pepper to taste. Stir in a quart of cornmeal. After simmering a few minutes, thicken it with buckwheat flour very thick.*

David Beissel's invention of home meat grinder in 1818 made preparing tender meat for scrapple a much easier process. No longer was scrapple made with chopping its tender meat very fine. Instead, the pork scraps were ground, creating a more well-blended product. Scrapple production was also revolutionized in the 1880s when the Enterprise Manufacturing Company of Philadelphia patented the first crank-turned meat chopper. The instruction booklet for the device even contained a scrapple recipe.

A Delectable History

What's in a Name

Although the Pennsylvania Dutch developed the dish in America, the name itself for scrapple was derived from Germany. The name developed from German word *scrabbel* and the English word *scrap*, both referring to leftover scraps of food. There is also possible influence from the German word *panhaskröppel*, which translates to a "slice of panhas," and *panhas*, which is a Palatinate word for any substitute, frequently consisting of scraps or leftovers chopped fine and prepared in a pan.

In rural counties of Pennsylvania, it is also referred to as *panhas*, which translated to "pan rabbit." One popular explanation of this name revolves around English settlers making a dish that resembled scrapple but contained rabbit as the protein. The German settlers then took that dish and substituted pork. The literal translation of pan rabbit is *panhas*. Spelling variations have existed through the years, including *ponhoss* and *panhaas*. "A great many fantastic explanations have been given of the derivation of this term, but it is simply one of the humorous names similar to Welsh-rabbit, for a mixture made from cheese, or Leicestershire plover, for a bag pudding," said the late Dr. D.W. Nead.

The word *scrapple* can also be found in English manuscripts dating back to 1397. The name referenced an ancient cooking utensil used to scrape pork skins when making sausage. Food historian William Woys Weaver traced *panhas* back to the 1500s, suspecting that it may have derived from the word *panna*, a type of Celtic vessel. If used in this way, the dish's name would be explanatory of the vessel in which it is cooked, similar to items like terrine and chowder.

Scrapple Growth

In the mid-nineteenth century, farmers began to take hours-long trips to the big city, Philadelphia, to sell their down-home country dish. New city dwellers who had recently arrived from farmlands rejoiced at the convenience of accessing their favorite farmhouse dish without the days of work.

The breakfast food became associated with Philadelphia, even if it was actually developed in its surrounding farmlands. It would be first introduced to urban housewives as "Philadelphia Scrapple," many of whom became repeat customers of traveling farmers and quickly loyal to their product.

As industrialization boomed in the city after the end of Civil War, in the late nineteenth century, the sweeping East Coast region experienced a decrease in family farms and an increase in urbanization beyond Philadelphia, in its surrounding suburban counties of Berks, Bucks, Lancaster and Montgomery, as well as in the neighboring state of Delaware. The farm life situation continued to change, with farmers feeling that hours (and sometimes long full days) of butchering was not justified for the few hogs they continued to raise. But that wasn't the end of scrapple…just the beginning.

The Country Butcher

By the mid- to late 1950s, the specialty country butcher shop began to thrive, sprinkled throughout small towns and in Philadelphia. Farmers for generations, who gained much respect for their scrapple products and meat cuts, gradually gave up their farms to focus on a specialty: butchering.

Although farmers found success selling their wares in Philadelphia, the long trips to the city became tiring. Not to mention, town butchers had developed a reputation for their work. When the customer demand seemed right around the neighborhood, they would cease the daylong trips to the Philadelphia and instead focus on providing meat products for their neighbors close to home.

The old-fashioned butcher shop grew out of farmers' homes until business growth paved its way to the business's next steps, or the butchers would rent a stand at a local farmers' market until business warranted a store of their own. Country butchers provided quality products prepared the traditional way, like the customers used to on their own farms. They honored time-tested recipes from their families, like that of scrapple, which those in the community appreciated as well. And they took pride in fulfilling the culinary needs of the neighbors. It was a win-win for all members of the community.

Meet Mass Production

By the late nineteenth century, most Americans had stopped butchering and raising their own meat, and it was companies like Habbersett Scrapple, Hatfield Quality Meats and Rapa Scrapple that had picked up the slack.

Godshall's Scrapple stocked in the butcher case at L. Halteman Family Country Foods at Reading Terminal Market. *Amy Strauss.*

As the slaughterhouse industry grew because farmers gave up the hard labor that it entailed, scrapple became more and more a commercialized byproduct of that industry. With a hole in the market opened by former farmers, these meat production companies were able to thrive commercially in the name of scrapple.

The rise in scrapple's popularity lead to it starring greatly in both high- and low-end situations. In 1899, the Pennsylvania Society of New York hosted its First Annual Dinner. In its records, it discussed that members were very pleased that the Pennsylvania diet had refined and enlarged—nodding to scrapple itself and serving it as a part of the feast. (They also cast shame on Pennsylvanians' previous diets, which were said to have consisted in great part of what is known in New England as hasty pudding.)

With any popularity comes imitation and flattery. By 1918, Robert T. Hogg of Oxford, Pennsylvania, had issued a patent request for his food invention that was intended as a substitute for, and to stimulate what is known as, scrapple. His patent request read, "In producing my improved product, I substitute for the pork or beef, milk or a milk product, thereby obtaining an article of food which very closely resembles 'scrapple' in appearance, but is less greasy and more palatable and nourishing."

His product was said to be equal parts cornmeal, whole rye flour and oatmeal, mixed to a batter with condensed milk. The porridge would be poured in loaf-like molds and chilled. It would be fried in slices like scrapple.

By late 1920s, scrapple was able to make the successful shift to a mass-produced, modern-day packaged food product, readily available in Philadelphia area grocers.

Frederick A. Vogt, of Philadelphia, strived to overcome scrapple's limited shelf life by issuing a patent in 1933 to can scrapple, which would allow the "product could be kept indefinitely and the quality of scrapple would improve." It read, "Scrapple is put on the market, either by supplying the retailers with open pans filled wherewith, or by molding the scrapple in smaller pans, and wrapping the molded product in individual packages that may be sold in wrapped form to the consumer. Scrapple marketed in either of these ways is capable of being kept only a relatively short period of time....Attempts have been made to can scrapple, because of the inherent advantages of marketing in this form."

Vogt's mission worked, with scrapple producers clinging to canning method for a few decades to make the product a pantry staple, like Spam. Customers could have a Philadelphia-style Sunday breakfast at a few moments' notice, without worrying if their scrapple had gone bad. Through

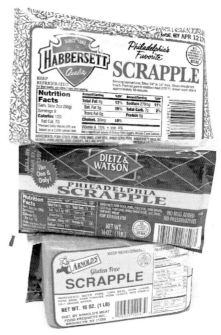

Above: Canned Strode's Country Scrapple. *Adam Peterson the Friends of Strode's Mill.*

Right: Product shot of range of brands and varieties found in the Philadelphia market—Habbersett, Dietz & Watson and Arnold's. *Amy Strauss.*

the years, Yoder's Country Market, a Mennonite-run bulk food business in Madison, Virginia, that continues to can other meats like bacon, and the now-defunct Strode's scrapple of the historic Strode's Mill property in Chester County (once one of Pennsylvania's best producers) became known specifically for their canned products. Eventually, the canned phenomenon died down, proving not as fresh as the vacuum-sealed, plastic-wrapped product stored in grocery chains in the refrigerated aisles.

By the 1940s and 1950s, it had become very popular for meatpackers to sell millions of pounds of scrapple. "The lean meat (from the hog) would go into sausage; the skins, livers and hearts went into scrapple," said the late Ed Habbersett, former president of Habbersett Scrapple. Scrapple also came under the watchful eyes of the U.S. Department of Agriculture Inspectors, and I'm sure the common myth that scrapple is made with "stuff they sweep off the meat house flour" never helped scrapple's case with inspections.

In the twentieth century, scrapple became a metaphor for Philadelphia but also the butt of jokes. Food historian William Woys Weaver has noted, in good humor, that if you'd "change the name [of scrapple] to *polenta nera* [black polenta, or polenta made with buckwheat], you could sell scrapple

in any upscale restaurant." The name had contributed enormously to its bad reputation.

Scrapple did have some good fortune, too, even if America did not. It experienced tremendous growth during the late 1970s and early 1980s during the recession, being seen as an economy dish. Due to the product's affordability and capability of feeding a family of four, scrapple sales soared high. Not to mention, it piqued shoppers' interest for possessing less fat than the equally affordable hot dogs, ground beef and sausages. A similar resurgence of popularity for scrapple had come during the Depression and World War II, when it was a meat product people could buy without ration stamps.

Philadelphia continues to concentrate on food that "fills big men up fast," with decades of locals picking up the scent and sizzle of the beauty of scrapple from the Pennsylvania Dutch. Although scrapple remains largely a product of the Mid-Atlantic region, you'll find it carried westward thanks to Amish, who shared the recipe as they relocated to isolated communities as far as Indiana and Ohio. Other cultures have interpreted it or devised their own renditions of meat mixed with meal, like Italian polenta, Romanian *mamaliga*, liver mush and *goetta*.

Now knowing scrapple's tangled, complicated web of hard work and stability, sustainability and cultural richness, let me reignite a crusade that historian Finkel boldly launched back in 1987 as part of a Historical Society of Pennsylvania series titled "The Larder Invaded: Reflections on Three Centuries of Philadelphia Food and Drink." He led a one-man campaign to get the pig snouts and other offending ingredients out of scrapple and thus restore it to its rightful position as Philadelphia's oldest and most historic foodstuff.

"Let's take the scrap out of scrapple," he preached. Proposing a new era for Philadelphia's oldest surviving breakfast food under a new name, "Philadelphia paté," he could help scrapple escape its bad rep. It may not have stuck then, but will it now?

HEAVYWEIGHT CHAMPS

Habbersett and Rapa Scrapple

So, you think you know who makes the best scrapple, huh? The brand you love—from Habbersett and Rapa, from Hatfield to Kunzler, Leidy's, Godshall's and so many more—come from similar beginnings, most of which started as a family affair and with a cherished family recipe. But what you may not know is that several beloved scrapple brands are actually made at the same facility, on the same equipment. A lot has changed since scrapple-making transitioned from a farm life chore, for winter substance, to a mass-produced meat product. Meet your makers—mass produced but still with Pennsylvania Dutch roots.

HABBERSETT SCRAPPLE

Ask a current Philadelphian or a Pennsylvania expat planted anywhere across the nation—or the world—what brand is their favorite scrapple, and you'll hear more often than not murmurings of "Habbersett."

Habbersett Scrapple is cited to be one of the country's first commercial scrapple producers, launching its business in 1863. But it was in the 1990s that its popularity reached an all-time high.

Let's rewind to 1993, at the first game of the National League Championship Series. CBS sportscasters Tim McCarver and Sean McDonough were bantering, somehow stumbling into a scrapple conversation on air. McCarver,

then a Main Line, Pennsylvania resident, began to share Habbersett's long history and then agreed with his co-anchor that it was made of pig intestines.

Habbersett's general manager, Tom Kennedy, was distressed by this news, so much so that he delivered nine pounds of scrapple to Veteran Stadium (now named Lincoln Financial Field) the next morning. Soon it became Habbersett's best, unintentional marketing campaign to date. Fans latched on to the mishap, throwing up a ragtag of signs at Phillies' games like "Let's *Scrapple* the Braves." Following the Phillies' loss in the World Series, Habbersett even ran an ad that read, "You're still the scrapple of our eyes."

Overall, the attention Habbersett earned in the game-watching arena enabled it to put its scrapple in front of the nation. It didn't hurt either that a few years earlier, in 1979, Pope John Paul II was served scrapple during his visit to Philadelphia and it was indeed Habbersett's product.

Habbersett received its early start in 1863 in Middletown, Delaware County, Pennsylvania, making it one of the Philadelphia area's oldest makers of the pork delicacy. At the start of founder Isaac S. Habbersett's business, he'd prepare scrapple for Philadelphia market in big iron kettles over an open fire. He'd trek

Habbersett Scrapple in stacked to capacity in a Philadelphia-area ShopRite. *Amy Strauss.*

down Baltimore Pike, then a dirt road, and on his return, he'd be on alert for robbers, who hid out in the woods around Clifton Heights. At its very beginning, scrapple was packed in stone crocks sealed with a layer of lard. This method became impractical as the business began to grow and was moved to fifteen-pound tins. These tins would be delivered to butcher shops throughout the early 1900s, where the butcher would slice whatever the shopper wanted off and wrap it in corn husks to maintain quality and protection. Eventually, through the 1930s, they'd test plain paper (it appeared too greasy) and waxed paper (the moisture still came through) until they arrived at cellophane to put their best appearance forward on the shelf.

Through the years and equipment and technology enhancements, the business thrived and was passed through many family generations. Habbersett developed into an iconic Philadelphia tradition—with Phillies' fans help, of course. Originally, it was located in Media, Pennsylvania, although now it's produced in Bridgeville, Delaware, in the same facility as Rapa Scrapple.

In the mid- to late 1980s, the rumor mill was ablaze as Habbersett toyed between moving its then Media-based facility to South Philly or Delaware. By 1985, it had been sold to Johnsonville Foods of Sheboygan, Wisconsin. Three years later, it sold it to Jones Dairy Farm in Atkinson, Wisconsin, which was a closely held family business that started in 1835 and jumped into meatpacking in 1889. It was the Jones acquisition that closed the Middletown plant in 1988 and moved operations to Bridgeville, Delaware.

The Habbersett company name and recipe were sold to Jones Dairy Farm as part of the deal, and its age-old formula is now mixed and cooked in same plant as its biggest competitor, Rapa Scrapple. How it works is the hog parts arrive at the Delaware facility in frozen blocks from Virginia suppliers. They are then loaded into one-thousand-pound pots and cooked until boiling. Flour, cornmeal and spices are added and cooked again until well balanced. Once the meaty porridge is complete, it's prepared for overnight chilling and then, as of the next day, wrapped and finalized for shipping. Last, the culinary bricks are stacked in refrigerated trucks and arrive soon at grocery stores near you. Habbersett sticks by its eighteen-day shelf life on its product, which is celebrated by endless scrapple zealots.

A good comparison to think about is that Habbersett Scrapple is to Philadelphia what Rapa Scrapple is to Baltimore and the Washington, D.C., area. Rapa's distribution is actually three times larger than Habbersett's. Rapa dominates 75 percent of the scrapple market in Baltimore and Washington, D.C., while Habbersett reigns over 50 percent of the scrapple market in Philadelphia. (Rapa has been able to hold 25 percent of Philadelphia's scrapple market.)

Jones Dairy Farm—with the production of Rapa, Habbersett and its own brand—is able to monopolize the world's scrapple market and be the largest producer.

Rapa Scrapple

Ralph and Paul Adams may have not been the first family to commercialize scrapple. They did, however, give birth to Delaware's scrapple industry when they cooked their first scrapple batch in their grandfather's Bridgeville butcher shop in the early 1900s. As the Adams boys' story records, the brothers slaughtered one too many hogs on occasion, and Grandmother Adams stepped in to create the family's first commercial batch of scrapple to make use of the leftover pork they couldn't sell. It became such a hit that the family left the sausage business behind to concentrate on scrapple.

By 1926, the brothers—whose names' initial letters form the company's name—built Delaware's first scrapple plant. Rapa made great strides since its founding through consistent quality and generations of customer satisfaction. Through the years, Rapa Scrapple defined itself on its level of quality and its willingness to experiment with flavored scrapples, like bacon and chile chipotle, as well as untraditional varieties like turkey and beef. The company obtains its pork trimmings from national manufacturing houses, including Hatfield and Smithfield.

In 1981, prior to the purchase of Habbersett, Jones Dairy Farm purchased Rapa. Following the acquisition, Jones doubled the size of Rapa's then sixty-year-old plant. There was even a time, in the early nineties, when Delaware's Department of Agriculture's marketing staff introduced scrapple to the Caribbean market, and it was well received. However, due to scrapple's limited shelf life, from fifteen to forty-five days, depending on the brand, exporting the down-home delicacy never got off the ground.

Jones Dairy Farm attributes the success of scrapple sales through its years largely to Philadelphians, who have lived in or visited the region and moved south or west and missed its taste. It's been harder to sell scrapple in areas where the locals are completely new to the product. Another big issue with keeping the distribution of scrapple localized to its plants is because of its short shelf life and the inability of anyone to successfully freeze the product to hit larger distribution.

A Delectable History

HATFIELD QUALITY MEATS INC.

After Habbersett, but before Rapa, there was Hatfield. For more than 120 years, Hatfield Quality Meats, headquartered in Hatfield, Pennsylvania, of Montgomery County, has operated as a family-run and family-operated meat manufacturer. But it was by humble circumstances the pork-meat manufacturing, which today manufactures more than 1,200 different pork products, came to actually become a wholesale business.

It all began in 1895. John C. Clemens, a Mainland, Pennsylvania farmer and distant relative of Mark Twain (aka Samuel Langhorne Clemens), was hauling pork products from his farm to be sold at the Ridge Avenue Farmers' Market in Philadelphia. It was a twenty-eight-mile journey and performed by a horse-drawn carriage. During Clemens's early days, he rarely made the trip to sell pork, fearing that there would be spoilage of the meat in the summer heat.

Eventually, Clemens's entrepreneurial skills inspired him to kick-start several businesses that revolved around his farm and butchering business, including what became known as the Pleasant Valley Packing Company, and servicing expanded Pennsylvania areas like Allentown-Bethlehem, Reading, Boyertown, Pottstown and Norristown.

Starting as early as the late nineteenth century, the Midwest and its production facilities dominated a generous part of the meat manufacturing market. But the coming of the coast-to-coast railroad enabled livestock to travel to the East Coast, and the introduction of newer technologies—including the refrigerated railcar and the time-saving truck—began to surface. Clemens was quickly recognized for his willingness to utilize new innovations to push his companies to their next step of growth.

Beyond traditional pork cuts, sausage and bologna were important manufactured products that helped Pleasant Valley survive during its challenging first years. Scrapple, too, was crucial for Hatfield's early success, one of its first products that was produced to cater to the business's massive customer base in the Greater Philadelphia area. It remains a mainstay item for the business and has contributed to the company's overall success. (After a disastrous fire in 1946 and a serendipitous opportunity to buy Hatfield Packing Company, which at the time was experiencing management and procurement difficulties, the Clemens family business took on the name of what it was buying: Hatfield Packing Company.)

Hatfield Quality Meats and scrapple are endlessly linked in history, as Hatfield was one of the first mass manufacturers to make it successfully and continues to produce it with consistent excellence for more than a century.

Pennsylvania Scrapple

Hatfield's Fully Cooked Lean Classic Scrapple. *Amy Strauss.*

In relation, sources like the *Los Angeles Times* have credited Hatfield Quality Meats as one of the largest producers of scrapple in the nation, citing that it sells upward of 50,000 pounds a week and 2.7 million pounds a year.

In producing scrapple, German bologna, bacon and sausage, among other items, by adhering to the importance of a quality product and service, the Clemens family was successful in matching or beating its national competitors.

It was between 1981 and 1994 that Hatfield experienced its biggest growth. Within this period, in 1987, it actually received its official name change we know today: Hatfield Quality Meats Inc. (It has since shortened its corporate name to Hatfield Inc. but still does business under its iconic name.) The business also began to expand its products into regional supermarket meat cases, like in Acme. (Previously, independent grocers and family markets sold the majority of its products.) In 1984, Hatfield aggressively increased its marketing efforts, hiring television personality Denver Pyle to be a product spokesman for one-pound scrapple and Jumbo Grillers (hot dogs). Scrapple sales doubled over the year, and more than ninety-one thousand pounds of Jumbo Grillers were sold in only six weeks.

A Delectable History

The family business thrived by sticking to regional roots and providing niche products like Pennsylvania Dutch meats. Many national producers easily overlooked selling something so regional as scrapple. By catering to a demographic that was largely ignored, it built a strong Pennsylvania Dutch customer base. The Pennsylvania Dutch community appreciated its product lines built on quality and tradition, in addition to the fact that the producer stuck to core values and high-quality standards and remained rooted in the Greater Philadelphia area through all its years of operation.

Hatfield Quality Meats has had a geographical advantage—it was closest to its largest consumer base, so in turn, it could guarantee a readily available supply of fresh products.

No matter how much growth the company experienced, Hatfield's family recipe for lean pork scrapple remained unchanged for generations. It's made from lean ground pork (pork livers, skins, hearts and tongue included) and a signature blend of cornmeal, buckwheat and select spices. These ingredients are cooked in stainless steel kettles until the mixture reaches the ideal consistency. Once poured into pan containers, the end 97 percent fat-free product is chilled for twelve hours, inspected for consistency and quality, vacuum-sealed and shipped to local retailers.

Hatfield also produces beef scrapple, made from the combination of beef stock, beef, beef hearts and beef liver and mixed with yellow cornmeal, buckwheat flour and wheat flour.

Leidy's

If you're keeping a scrapple timeline, after the birth of Habbersett Scrapple, but two years before Hatfield's start and more than two decades before Rapa made its market debut, came Leidy's in 1893 in Souderton, Pennsylvania.

Leidy's operated as family-owned and family-operated brand until 2008, then undergoing a company merger with an equally midsize and family-owned meat processing company, Alderfer Natural Wood Smoked Meats, in 2008. (The merger enables the two businesses to collectively produce 1,300 different products, including scrapple.)

Throughout the company's history, it has specialized in working with small family farms that are committed to raising hogs in stress-free, humane environments with all-natural diets. All the pork manufactured and sold as part of the Leidy's brand is grain-fed, Pennsylvania farm-fresh, all-natural

and, interestingly enough, traceable—the company is able to tell you what Pennsylvania farm the pork in your scrapple came from. Cool, huh?

The original Leidy business spawned from a family farm that was started in 1753 by Jacob Leidy, a German Mennonite immigrant, with the help of a Philadelphia land grant. The company began by selling its products (meat and produce) at markets in Montgomery County. The emergence of the railroad in the 1860s enabled the family to sell its products in Philadelphia as well. But it wasn't until Jacob's son, Milton Leidy, took the business by its horn in 1893 and made it a commercial business that its scrapple story truly began.

Like similar farm turned commercial family businesses, Leidy's slowly began to sell to regional grocery stores and butcher shops. Over the years, customer demand led to expanded distribution, product production and sales, until it had grown into a multimillion-dollar business.

The Leidy's scrapple recipe continues to hew closely to its original 1893 recipe, making use of pork with skin, cornmeal, pork livers, pork skins, pork tongue, pork hearts, whole wheat flour, salt, onions, spices and no preservatives.

Leidy's, like the Rapa Scrapple facility, acts as contract producer for smaller scrapple producers that have outgrown their production space. Harry Sheldon, of Haines Pork Shop in Mickelton, New Jersey, started working with Leidy's in 2014 to produce more than four hundred pounds of scrapple for his business. Leidy's follows Haines Pork Shop's original recipe in production, one that dates back to around when the Civil War ended, in 1865. The relation comes in via Sheldon's wife, Margaret, the great-great-great-granddaughter of the enterprising Rachel Haines, who used to hitch up her wagon in autumn and make the rounds with farmers slaughtering their pigs. She'd then turn their piles of carcasses into money in the form of the compact, tasty loaves. (The Haines recipes does not make use of buckwheat, instead using wheat flour mixed with cornmeal, which may contribute to its unique taste.)

ADDITIONAL LEADING SCRAPPLE MANUFACTURERS

Through the years of scrapple's manufacturing heyday, regional meat manufacturing companies tapped into the product's popularity—many of which continue to produce scrapple today.

Godshall's, once a single butcher's shop with two employees in 1945, has expanded into a thriving premium meat purveyor with facilities in Telford and Lebanon, Pennsylvania. It continues to garner popularity for its country-

made turkey scrapple, which it bills as a "healthy alternative to pork scrapple with lower carbs."

Kunzler & Company Inc., like Godshall's, got its start as a small butcher shop. Led by German butcher Christian Kunzler, who settled in Lancaster, Pennsylvania—where the company remains today—the company continues to specialize in fine meat products that are influenced by old-world German traditions. Now led by its fourth generation, Kunzler's Pennsylvania Dutch scrapple remains one of its top sellers. The company crafts it the traditional way, with its own blend of spices, and makes use of just whole wheat and cornmeal, celebrating that pork liver is a substantial part of the product. (It also sells *braunschweiger*, a very soft, spreadable pork loaf like scrapple that features a distinctive spicy liver-based flavor.)

In 1939, Gottlieb Dietz founded Dietz & Watson in Philadelphia, and the brand remains a household name well into the twenty-first century. Dietz & Watson continues to be a family-owned and family-operated enterprise, now in its fourth generation, spearheaded by CEO Louis Eni, the son of the famous "Mama" Ruth Dietz. (Louis first job at Dietz & Watson was at the age of sixteen, separating hot dogs by hand and stuffing them into their casings. "It was harder than you think," he said.) Headquartered in Philadelphia, Pennsylvania, and with facilities in Baltimore, Maryland, and Corfu, New York, the company continues to celebrate the region in which it has thrived by billing its product as "Philadelphia Scrapple." It also boldly markets itself as selling the "only true Philadelphia Scrapple in the market," and if you ask Eni what's his favorite Dietz & Watson product, he'll say the scrapple—hands down. Like Kunzler, it crafts its age-old, traditional recipe with additions of whole wheat and cornmeal—no buckwheat. Uniquely, it is keen in creating a product crafted with pork skins and

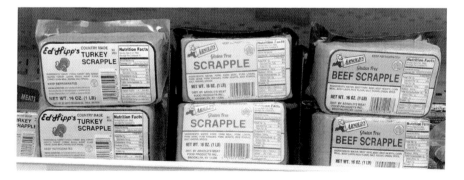

Range of brands and varieties, like Ed Hipps's Turkey Scrapple and Arnold's Pork and Beef Scrapple, found in the Philadelphia market. *Amy Strauss.*

Pennsylvania Scrapple

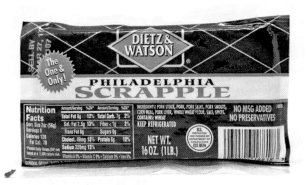

Product shot of Dietz & Watson Philadelphia Scrapple—"The One & Only!" *Amy Strauss.*

pork snouts and using the highest quality of fresh pork possible. Eni revealed that the company produces much of its scrapple inventory in the fall and winter months, which is aligned with its highest customer demand. For years, Dietz & Watson has operated by the business philosophy of avoiding shortcuts in every process to ensure a product's highest potential, flavor and quality, so scrapple-making continues to be a daylong affair at its headquarters. It's even made in a designated "scrapple" room. (The kettle cooker was a sight to see!) Dietz & Watson is cited to be the second-largest deli meat processor in the United States, with Boar's Head as the largest. It is the last standing Philadelphia-based manufacturer of scrapple.

It was William Newman who, in 1967, founded a hot dog and bologna company in Brooklyn, New York: Arnold's Meats. From what began as a small Greenpoint, Brooklyn neighborhood market became an expansive meat business that, over the decades, expanded into two facilities in Brooklyn and Pennsylvania. Still family-owned, Arnold's Meats grew into producing smoked sausage and then further expanded into down-home staples like scrapple, chorizos, kielbasa and bacon. In addition to traditional pork scrapple, Arnold's also creates beef scrapple, crafted with beef hearts and beef liver.

Scrapple Producers of Yesteryear

At the start of scrapple's commercial success was Burk's Sausage Company, which began selling scrapple in 1881 in Philadelphia. Led by Louis Burk, a native of Philadelphia and a "practical and skillful exponent of his trade," the business was run off steam power, and his trade products extended throughout the city, winning him general regard in commercial circles.

Although successful in the nineteenth century, Burk's was taken over by Bernard S. Pincus in 1916.

The Pincus company and its scrapple and other sausage products were billed under the brand Yankee Maid. The scrapple recipe at Pincus was a combination of a house recipe and Burk's original. Although Pincus himself wasn't incredibly knowledgeable of the traditional product, he did employ Pennsylvania German workers, who helped refine and perfect the recipe. The Pincus recipe was crafted with stone-ground cornmeal and a mixture of rye base and wheat flours.

Well into the 1970s, the Bernard S. Pincus Company heavily marketed its scrapple and found success for it in areas as far as Harrisburg and New Jersey but found difficulties in garnering attention for the product in more distant areas. It also found it necessary to provide exact directions for preparation of the product, as some consumers lacked understanding of the product.

Nearby, in Chester County, Pennsylvania, resided one of the premier producers of scrapple. Strode's Pork Products, which operated on the Strode's Mill estate just south of West Chester, was highly regarded for its quality sausage and scrapple. Brothers Marshall and Francis Strode founded the family slaughtering and sausage business as of 1875, and it was Marshall's son, Amos Darlington, who was responsible making the products a Philadelphia tradition by selling them out of one of the original Reading Terminal Market stalls at the start of 1893. When Amos first started selling the family's products, he was one of the few suppliers of pork products in the Philadelphia region. Business expanded rapidly, and after a few years, Strode's Pork Products could be found on breakfast tables throughout the region and beyond.

Eventually, Philadelphia became known as the scrapple-making center in the country, and the Strode's product, embedded in family tradition and made from an age-old, traditional recipe, faced tough competition. However, the Strode's product was always remembered as one of the best, respected for the quality of its product—which was influenced by its choice of only slaughtering the younger, leaner stock of hogs raised on the farm, which was untypical of the industry at the time. Although the business was sold in 1983 to Daniel Weaver Company of Lebanon County, Pennsylvania, the Strodes' pork products are still regarded highly, especially in Philadelphia and among old Philadelphians.

If you drive by the original Chester County property, where production once was once alive in full force, you'll spy the family's original "country scrapple" sign painted larger than life on one of the still-standing barns.

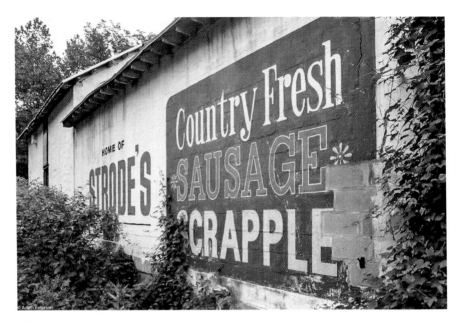

The Strode's Country Scrapple sign in Chester County. *Adam Peterson the Friends of Strode's Mill.*

Though distressed, it still remains today, reminding us with every drive about a quality product that once was.

Oscar Mayer Company, a well-known meat and cold cut production company founded by a German immigrant, Oscar F. Mayer, as early as 1883, already had experience in the sausage business when it tapped into scrapple. In 1949, Oscar Mayer bought Vogt's company in Philadelphia, which had been making scrapple since the turn of the century.

Under Oscar Mayer's leadership and development, it amplified the quality standards of Vogt's scrapple. (It also didn't help that Vogt's had begun packaging dog food at the same plant it produced scrapple right before the Oscar Mayer sale.) However, Oscar Mayer had its own challenges in selling scrapple. Its offices were based in Chicago first and Madison, Wisconsin, second, and it had only a small pretense and understanding of scrapple as a product and the regional popularity behind it.

With the help of advertising campaigns that stressed the beauty of scrapple as an economic breakfast and nourishing contribution to your first meal, Oscar Mayer saw the rise of the product. By the 1970s, it had begun to contemplate cancellation of its production, and eventually, it did. Oscar Mayer Company is now owned by Kraft Heinz.

IN CELEBRATION OF MEAT

Uncovering East Coast Scrapple Festivals

Ever dream of the opportunity of spending the day eating your favorite culinary scrap heap in all shapes, varieties and renditions? Dare to vie brands against one another to uncover who really makes the "best" scrapple? Interested in catching scrapple made the "old-fashioned" way in all its raw meat glory? You're in luck. The East Coast—and especially in the Philadelphia region—features a hotbed of original, wacky and seriously delicious scrapple-themed events that you will not want to miss.

APPLE SCRAPPLE FESTIVAL

Bridgeville, Delaware—the home of Rapa Scrapple—holds another scrapple claim to fame: the town hosts the annual Apple Scrapple Festival. (The town also hosts the World Championship Punkin Chunkin contest. Weird place.) The apple-meets-scrapple celebration brings more than forty thousand food lovers out for a two-day festival, all to celebrate Bridgeville's two major exports.

The community launched the first event in 1992 after devising a plan to better promote the Sussex County town and its successful agriculture industry, as well as fundraise to support the community and its organizations throughout the year.

Permanent Apple-Scrapple Festival sign in the town of Bridgeville, Delaware. *Amanda Hirsch.*

T.S. Smith and Sons Farm, an eight-hundred-acre family-owned farm calling Bridgeville home, opened in 1907 and operates as the oldest commercial apple orchard on Delmarva. It's progressive—it's solar-powered, has apple trees older than some of its workers and has provided jobs for the town in which it resides. Rapa Scrapple, opening in 1926, led Delaware in becoming the nation's largest scrapple producer through high-quality recipes and appreciation of traditions. Plus, it's impossible to drive through Bridgeville during the summer and not notice the distinctive smell of scrapple wafting through the fresh air.

Originally, in its early years, the Apple Scrapple Festival attracted about 2,500 people, but it has grown exponentially over the decades. The wacky October festival marries the likes of a country fair, a craft show, a performance art showcase and an epic display of scrapple like never seen before.

Ever wanted to eat more than ten different scrapple slices and sandwiches in one setting? This event is for you! Firehouses, ladies' auxiliaries, local restaurants and food trucks flip up their renditions for your hungry pleasure. Save room for the all-you-can-eat scrapple breakfast, though, as it serves the top-rated scrapple out of the entire festival. Apples are a-plenty too, including delicately dough-wrapped dumplings and fried fritters.

Things get very interesting when it comes to scrapple-themed festivities. There's a Little Miss Apple Scrapple pageant, hosted the Friday night before the all-day festival. Little girls ages five through eight are welcomed to compete, tasked with being able to take the heat while challenged with onstage interviews and performing a talent or giving a speech. Best part of all, the Little Miss Apple Scrapple gets to reign over the year's festival. Cute, huh?

There's the invite-only Scrapple Sling, where councilmen, the mayor and town council presidents compete to see how far they can sling a pack

of scrapple. (It's harder than you think, I hear.) There's a similar Scrapple Chunkin' Contest for the public, where shot put style is the means for throwing the porky scrap loaf. There are ranging classes for competing, where you would throw either a two-pound or five-pound package of scrapple. Ladies are encouraged to participate in the eight-inch cast-iron skillet toss, which has very serious and coveted cash prizes! (No practice throws are allowed on site—you've been warned.) Women have thrown the frying pan more than sixty feet in the past. As part of the throwing fun, kids get to challenge their strength in an apple-chucking battle.

For those health-conscious—do they go to things like this?—there's a 5K Hogg Jogg, which for me, is the best way to make more room for scarfing scrapple. But wait, there's more: a scrapple carving competition that invites those most crafty to chisel something grand into a one-pound loaf of scrapple under intense time restraints.

There is no better a way to live out your scrapple fantasies—all in one town. The Apple Scrapple Festival occurs every year on the second full weekend in October.

Reading Terminal Market's ScrappleFest

The iconic Reading Terminal Market of Philadelphia, known for its abundance of traditional Pennsylvania Dutch foods, local produce and family-run stands, hosts a biannual ScrappleFest. Over the years, the festival has developed what Marketing and Event Manager Sarah Levitsky coins a "weird cult following."

The market, located expansively on the bustling block of Twelfth and Arch Streets, has a long history in the center of Philadelphia—and scrapple has always been a part of that. The Reading Terminal Market was built by the Reading Railroad Company in 1892. (If you ever played Monopoly, that's one of the railroads that dominates the game board.) Through its long and interesting history—which at times were good and bad—it has emerged in the twenty-first century as one of the greatest public markets in the country and, specifically, the nation's oldest continuously operating farmers' market.

Back at its start, the railroad station was literally above the hundreds of market stalls, so shoppers could conveniently grab their groceries after they arrived. To understand the magnitude of vendors that were

A scrapple sculpture that appeared at Reading Terminal Market's bicentennial ScrappleFest. *Reading Terminal Market.*

cushioned into the stalls like sardines, it's important to compare the numbers operating today. In 2017, eighty stores operate within the market, and the market itself is completely maxed out. No one can open a business within its perimeter unless someone leaves or gives up their space. But back in the late 1800s, the market was so densely populated with stores that hundreds were able to operate within its walls.

"It has such history, there's a lot of nostalgia when it comes to Philadelphians and this market," Levitsky continued. "The city was literally ready to tear it down and turn it into a parking lot. Philadelphians banded together and saved it. The manager at the time, in 1980, was thinking forward and he decided to try to repopulate the market as a way to also save it. That's when he brought in merchants that he recruited from Booth's Corner, a traditional Amish market."

A majority of the merchants to this day are descendants from those who packed the market's revitalization in 1980. "They are a big part of our identity—people [who] bring their culture and high-quality product with them," she continued. "Of course, the farm-fresh produce and meats too."

A Delectable History

The market continues to specialize in customized service with butchers; old-world ways of doing your shopping; and thirty restaurants, each with its own niche and quirky events—like ScrappleFest—that showcase something unique about its identity. It also continues to be a sea of scrapple, with virtually every meat stand and breakfast place selling it. "We like to host events that showcase the diversity of Philadelphia and the diversity of the market. For ScrappleFest, it's run unlike any of our other events. We bring in the companies that make scrapple—all of which are sold here and be purchased to enjoy later."

Festivalgoers get to sample scrapple from every last one, and some offer optional toppings—sometimes it's ketchup and sometimes it's maple syrup, which always "causes a major discussion. People are very loyal to their scrapple brands. They will not eat it if it's not their own scrapple brand. So, it's fun for people to be able to, in a sampling setting, taste the different ones and say, 'Yes, I like mine the best!'"

In 2011, an Oregon-based producer, West Coast Scrapple, even trekked to the opposite coast to participate in the event. Slinging what it coined as "redefined" scrapple, crafted with lean, high-quality pork, it was its first public debut and, in the city of Philadelphia, perhaps its most critical tasting to date. The founders and creators, Michael Susak and "Uncle" Steve, sampled their healthier scrapple to the masses, serving a sum of up to twenty-two thousand festival attendees. Although attendees looked at the duo at first with an eye of skepticism—"how could someone from the West Coast made real scrapple?"—the pair quickly revealed that their great-grandfather was a Pennsylvania native, moving from Harrisburg, Pennsylvania, to Washington State in the early 1900s. It was their family alone who bred the scrapple movement on the West Coast, re-creating the one-hundred-year-old recipe for family functions and the holidays. (They also create a wheat-free and a salmon scrapple, but you'll have to discover that for yourself.) But it wasn't until ScrappleFest that they took the idea to mass-produced markets and selected

Hatfield pig mascot making its rounds at Reading Terminal Market's ScrappleFest. *Reading Terminal Market.*

Left: Dietz & Watson prepares slices of its Philadelphia Scrapple at Reading Terminal Market's ScrappleFest. *Reading Terminal Market.*

Below: Competing scrapple sculptures at Reading Terminal Market's ScrappleFest 2009, including a 1954 replica of the Chevrolet refrigerated delivery truck. *Reading Terminal Market.*

Reading Terminal Market's own event and festivalgoers to act as their first official test audience.

Unlike other events at the market, where vendors are sampling their goods for event attendees, at ScrappleFest they are strictly participating in friendly competition. Merchants participate in a scrapple recipe contest—some of which never even serve or prepare scrapple. Previous competitive dishes have been a scrapple pretzel roll, scrapple breakfast pizza, scrapple bread pudding, scrapple sashimi, mahi-mahi scrapple hushpuppies, panzanella salad featuring scrapple and peach Dijon-glazed turkey scrapple meatloaf.

They also bring in three judges to award the best scrapple dish in the market. "It's become a coveted trophy," said Levitsky. (It's a nifty plaque with a pig on it.) "As a non-meat eater, my boss always jokingly asks permission for me to do ScrappleFest. I always say, 'As long as you don't make it eat it.'"

Kutztown Folk Festival

Since the summer of 1950, twenty-five thousand festivalgoers have flocked to the Kutztown Fairgrounds in Kutztown, Pennsylvania, in Berks County to take part in the annual nine-day Kutztown Folk Festival. Organized each year during the Fourth of July week, the unique, hands-on festival offers a glimpse into the traditional folk life of Pennsylvania Dutch families, including live demonstrations, music, crafts and, most importantly, endless authentic foods—so much so that the phrase "eat till ya ouch" still has great meaning as it continues to tempt visitors.

A quintessential display at the festival is the demonstration of traditional scrapple-making, which typically occurs twice during the course of the nine-day event. Newton Bachman, a former country butcher of Kempton, Berks County, Pennsylvania, was one of the more notorious demonstrators of the decades-old festival, particularly in the 1960 and '70s, when he led butchering and scrapple-manufacturing demonstrations for festivalgoers.

He was a wealth of knowledge, educating curious scrapple eaters about its history, including the fact that years ago, scrapple only existed in the wintertime. In a thorough interview in *American Folklife* magazine, he relayed similar storytelling about how a farmer butchered about two times a year, and when he did, scrapple was made with the trimmings, a byproduct of butchering day that would feed the family the rest of winter.

Pennsylvania Scrapple

At times, he said, if the weather was not cool enough, the butchering day would need to be postponed. Scrapple would be stored in the family's ground cellars, where they could keep it for a few months. But as butcher Bachman suggested, hogs then were much fatter. Butchers purposefully wanted lard and made their hogs fat. They'd prepare scrapple from these hogs, filling pans three-quarters full with scrapple and reserving the last fourth to top with lard. Lard would preserve the scrapple and extend its shelf life because it sealed off any air. When you wanted the scrapple at a later date, you'd just scrape away the layer of lard—lo and behold, the scrapple remained fresh.

Along with the process of making scrapple, other products would be composed. After the meat had fallen off the bones and was ground, a portion of it would be reserved and put in casings or crocks for liver sausage or pudding. (At Kutztown Folk Festivals, he demonstrated how to make both scrapple and liver pudding like "it was done on the farm years ago.")

Another beloved Pennsylvania German and traveling butcher, George Adam, demonstrated scrapple-making for many years at the festival and was known as farmer butcher who was ready to assist at a moment's notice. George was so skilled at making scrapple that he developed a reputation for being able to travel to any farm site to assist with its production. He would even bring his large iron kettle, sausage stuffer and all the necessary butcher equipment to complete the service. All the farmer would need to acquire was firewood and water.

Because of Adam's skill sets, a special butchering house was built for him at the Kutztown Fairgrounds (meeting the board of health requirements), one that allowed tourists to witness the complete butchering and scrapple-making process in its entirety.

He was a wealth of knowledge, too, sharing with wide-eyed—and perhaps terrified—attendees that winter/Christmas butcherings were remembered best among the Pennsylvania Germans. A traditional German custom was to share your day's butchering with your neighbors, so gifts of homemade sausage and scrapple would arrive on doorsteps, as well as be gifted to those most in need.

While the old-time demonstrations are reason alone to trek to Kutztown for the folk festival, several food vendors serve scrapple sandwiches as well. The scrapple is sliced thin, crisped around all its edges and stuffed between two slices of white bread. It's up to you to then decide if smearing condiments are in the cards, or if you're a purist and keeping it simple is the key to your scrapple-eating heart.

A Delectable History

Goschenhoppen Folk Festival

Like the Kutztown Folk Festival, the Goschenhoppen Folk Festival revisits the region's agrarian and Pennsylvania German roots. Organized on the Goschenhoppen Historians' Henry Antes Plantation, in Upper Frederick of Montgomery County, Pennsylvania, for fifty-one years, the festival specializes in showcasing the trades and home skills of the Pennsylvania Dutch in the eighteenth and nineteenth centuries.

Since 1966, nearly five hundred costumed volunteers have banded together to re-create kitchens, trade shops and itinerants to bring to life the hands-on skills from the past. A highlight of the annual event for many are the sometimes gruesome and bloody pig and steer butchering demonstrations, which follow centuries-old methods to illustrate what life once was like for our Pennsylvania Dutch ancestors of the past. Once the butchering is complete, scrapple production begins for onlookers, finally enabling them to uncover what the heck goes into that fine meat.

Around the grounds, you'll also spy nineteenth-century cast-iron stoves already at work, stewing up dishes whose roots date back as far as—or farther than—scrapple's beginnings. Expect everything from chow-chow and pies in process to pig stomach stewing away.

As of 2014, the Goschenhoppen Historians Inc. have made available for purchase the bacon, sausage, scrapple and ground beef from the butchering demonstrations to enable visitors who have a new spark for the taste of history to take a piece of it home with them.

ON THE FARM

Generations of Families Continue Scrapple-Making Traditions

In 2011, Travel Channel's *Bizarre Foods with Andrew Zimmern* took the show on the road to White Haven, Pennsylvania, Luzerne County, to visit Redneck Ranch, where the host would undergo an entire day's affair of pig butchery and scrapple-making the traditional way.

Zimmern wasn't the only TV host aiming to throw scrapple and its traditional farm manufacturing in the limelight. More than a decade earlier, in 2000, celebrity chef Bobby Flay hit Lancaster County, Pennsylvania, on the first season of his Food Network show *Food Nation* to see how it authentically was made. In Glenn Bendle's kitchen, he and the camera crew crowded around for what had to be hours, stewing and grinding the meat and mixing it with all its additives.

Jim Werner, a longtime Philadelphia resident who had eaten scrapple since his childhood, took part in the television show filming. "As they were in their kitchen making it, we were in the background playing music for the show," he said. "I was on the show because of the Mummers—but we wound up doing a whole scrapple segment. It interesting to watch them make it homemade. That was the only time I ever saw someone make scrapple in my life and I couldn't believe how much work went into it."

Like Werner and many television viewers, the tedious act of butchering your own animals and stewing your own leftover scraps to produce loaves of meat wouldn't typically be a task you'd be looking to conquer over a weekend. But for centuries, it was the way of life. It was by daily farming chores like butchering that the younger generations became schooled in the

A Delectable History

Pennsylvania German culture and garnered respect for the proper use of a butcher bench. It was a common sight for a Pennsylvania Dutch farm butcher to have stacks of scrapple pans, sometimes nearing one hundred, that they'd file like soldiers on their bench to chill in the winter night to complete the day's scrapple-making.

As the times modernized and farm families sold off their properties for simpler ways of time, butchering benches and cutlery, scrapple-making kettles and equipment were auctioned off at estate sales. They were a heartbreaking testament to families' once-common purpose of living off their land and animals, spending days preparing substances like scrapple to support the family through cold months. With a mass-produced product flooding grocery stores and your local butcher taking care of the grunt work of crafting the pork mush, many no longer found the need to spend a day sweating, meat-picking and stirring to call a scrapple their own.

But that's not to say farm families have gone extinct! The act of making scrapple the "olden way" remains a recurring feat of the year, repeated for several generations as tradition and as an act of producing a product that is just the way the family likes it. Thousands of farm families in Pennsylvania continue to make their own scrapple in the winter—sometimes all year, too, including those as-seen-on-TV on the Redneck Ranch and a close-to-Philadelphia Pennsylvania Dutchman, Barry Schwenk of Douglassville, Montgomery County.

The tradition of making scrapple with his family started since the day he started to crawl. Then he lived on a family farm in hidden hills of Perkiomenville, Pennsylvania, where his family butchered each and every year. "When I was a young lad, I would be out there watching," Schwenk recalled. "At a young age I got to help, I got to stir, help grind the meat and do some of the odd things. When I got older, my grandparents passed away and we kept it in the family."

Now seventy years old, he continues the traditions of butchering and making scrapple from the day's scraps with his extended family. "We have the original equipment from about four generations," said Schwenk. "Still to this day, we make it the old-fashioned way. The equipment we use includes a kettle that holds 320 pounds and an old-fashioned hand grinder."

Once a year, sometimes up to three times if he's lucky, he gathers the family on a brisk Saturday in winter to assist with the age-old process of kettle cooking a large batch of scrapple. Winter is the only time Schwenk is able to make scrapple since he can let it chill overnight in his barn versus having to find refrigeration for every last pound.

Pennsylvania Scrapple

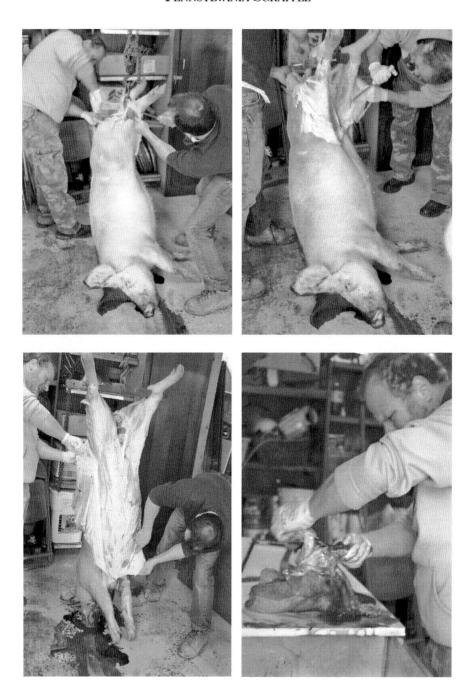

Top row and bottom left: Butchering day on Barry Schwenk's farm. *Amy Strauss.*

Bottom right: Terry Schwenk butchering meat, saving all possible scraps for scrapple. *Amy Strauss.*

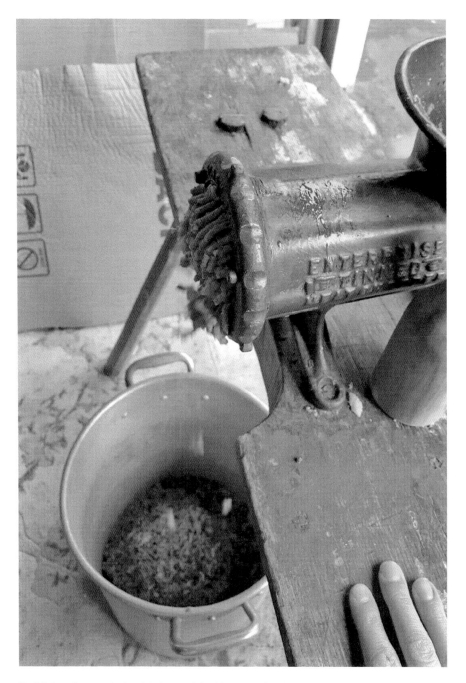

Pork is hand-ground after it is hand-picked by many family members on Barry Schwenk's scrapple-making day. *Rachael Schwenk.*

Pennsylvania Scrapple

It was two degrees outside on the coldest day he's ever made scrapple. But a little winter weather never stopped him—nor his family, who come out in herds to lend a hand in the daylong process. (In 2015, his family participated three times in the dead of winter, producing an astonishing 935 pounds of scrapple.) "We get all family members and friends to help and make a day of it," he continued. "I get up at 3:30 a.m. in the morning to get things started. I have the kettle prepared the night with before with the meat in it and all I have to do is light the wood fire underneath it and scrapple-making is underway." (He could switch the heat source to gas but doesn't want to stray from the old-fashioned way of cooking scrapple.)

Of course, the process itself starts days before with killing and butchering the animals. "All the meat you need for the scrapple is the trimmings you have left from the animals you have butchered." Schwenk's family has traditionally made scrapple from the combination of scraps from a pig and a steer. After he and his family have cleaned all the trimmings from the butchering day, he puts the raw meat in the kettle. That consists of the trimmings of both the pig and a steer—the bones, heart, liver, tongue and tail. "For us to make a 320-pound batch of scrapple, we'd use about 120 pounds of bones and meat and cook it down in the kettle."

After the meat is put into the kettle, he covers it with water and cooks it until it is finished. "Every now and again, I have to stir the kettle with my big wooden paddle. You wouldn't believe the smell of the meat cooking. It smells so good!"

That'll take a few hours, he advises, until about 6:00 a.m., so he bundles up, sitting by the fire while music croons from his nearby radio. Sometimes his grandson joins in, not thinking twice about the early morning wakeup call to keep him grandfather company. Soon, more help arrives, with a rough range of ten to twenty-two family members signed up each year to participate in the old-fashioned festivities. "This is where the scrapple process *really* starts. I let the fire die down, and we start taking all the cooked meat out of the kettle."

With a generous-sized colander in hand, he scoops portions of the meat until the kettle shows just the remaining broth. He places the colander over a twenty-gallon pot, to reserve every last drop of broth that may drain from the meat pieces. (You'll need to save that juice for later.)

The meat is piled high into a five- by four-foot stainless steel tray, and the family files around its perimeter like hens pecking for dinner, picking away the meat from the bones. "It's a whole production. We make sure no little bones make it through."

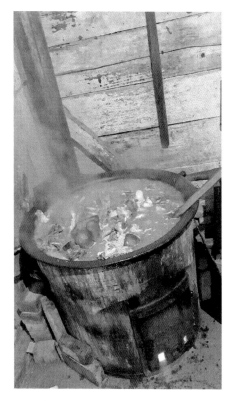 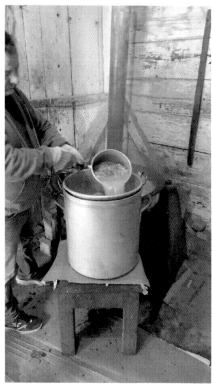

Left: The Schwenk family starts its scrapple-making day by boiling various pig parts with their bones for a few hours until the meat becomes tender. *Rachael Schwenk.*

Right: Barry Schwenk Jr. removing cooked pig parts from their resulting broth in order to prepare for removing the meat from the pig's bones. *Rachael Schwenk.*

While meat-pickers are elbows deep in bones, Schwenk's youngest grandson, Cole, begins to grind the meat. He took on his now permanent grinding job when he was ten. (He's now fifteen.) "It's an old-fashioned grinder, so it's hard to crank. At first, we had two guys helping Cole. Now he does it himself."

Since the bones' job is to give the broth "all the flavor," their job is done is after the first boil. They are then discarded, and the broth is poured back into the bare kettle by the strongest of the family members. (It's very heavy, I hear.)

Schwenk fires up the kettle again to get the broth boiling. "I'll add a little bit of water to break it down a bit, and we'll start adding the seasonings—salt, pepper, etc. On the side, I'll take white flour, put it in a bucket with cold

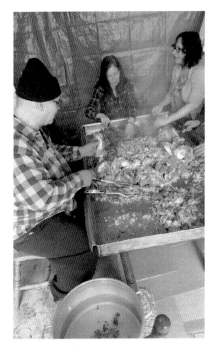

The Schwenk family (Bryan Helsel, Bonnie Davidson and Christy Kissinger) all chip in to hand-pick meat from the pork bones.

water and blend it to make a slurry. We dump that into the broth very slowly, stirring as it is again."

His pro-tip word of advice is that if you add white flour in any other way, your scrapple will get lumpy. As soon as white flour hits the broth, the fat within it collects the white flour and creates lumps. But if it's a slurry and you mix it in the broth, you don't have any lumps.

As more than five pounds of ground meat begins to collect, courtesy of grandson Cole Schwenk, they slowly begin to add it to the liquid mixture. The wood fire below continues to flare, the boil eager to roar once more, and everyone takes a turn stirring the porky porridge nice and slow.

Soon, a couple pounds of flour—first buckwheat, then wheat flour—and cornmeal are blended together and thrown into the kettle. Family members take their turn stirring figure-eights into the mixture, pulling the flour mixture down into the stewing kettle to bind all the proper ingredients. Black pepper, salt, sage, oregano and a lot of coriander—that's what gives your scrapple flavor—are generously sprinkled into the mix while stirring never stops. Everyone's muscles work to bring this beast of a batch to its necessary place. "After a period of ten minutes or so, everyone gets a spoon and we do a taste test. I have four or five guys that I can trust and know 'the taste' that we are looking for."

The familiar "taste" isn't as easy as you think, though, because every pot is different. Each butchering day warrants a different end result, depending on the size of the pig and steer and the amount of scraps that closed out that day. "It all depends on what you have left over after the animal is killed. That's what determines what you do."

The process is easy after that, he laughs, although some are already exhausted from the morning's work. "You keep putting more flour in, and every time you do, it dries out the fat and juices and thickens. We keep stirring and stirring until it gets thicker and thicker."

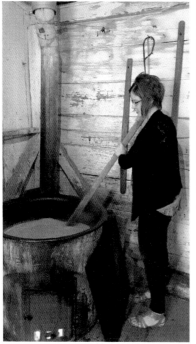 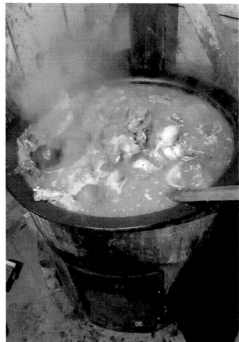

Left: Rachael Schwenk, Barry Schwenk's niece, stirs the family's three-hundred-pound batch of scrapple as it's in the making. *Amy Strauss.*

Right: A close-up of the kettle stewing with various pig parts stuffed inside, cooked for hours until the pork becomes tender. *Rachael Schwenk.*

The scrapple mixture will be stewed until noon, with the family testing the bubbling product every ten to fifteen minutes to double-check if more salt or pepper, or other seasonings, are needed to elevate the batch's overall flavor profile.

Eventually, the wood fire's embers die down, which you want, as to not burn your scrapple. Schwenk revealed two tricks of his trade as you near the end of the cooking process: "You know it's done when you take your stirrer, scoop it under, pick it up and if the scrapple holds to it without running off, that's a good indication that it is done. The real test is if you stick the stirrer in the center of the kettle and it stays—without moving one inch."

Schwenk's final scrapple-making step involves each family member lending a share of help. With one- to ten-pound pans in hands, they form a conveyer line of people from the kettle to the trays, where they will sit overnight. One by one, they fill their pans and walk the warm scrapple to its

final chilled resting place. The line of people doesn't stop until the kettle is completely emptied. "We have a train from the kettle to the tray of people filling the pans. It's just so much fun."

The pounds of scrapple will chill overnight, but by Sunday, every last one has found its future home. "I usually take orders and call everyone when it is ready for pick up. 90 percent of the scrapple goes to the family. I have a list that I can never fill and even if I made it ten times a year, I'd still need more."

Barry Schwenk Sr. with son, Barry Jr. (*far left*), and two grandsons, Cole and Barry III, on scrapple-making day. *Rachael Schwenk.*

But, why continue making scrapple—especially such a large batch—when it's so readily available at local grocery markets and is such time-consuming work? "I've done it so long, it's in my blood. Skeeter, my brother [Terry], was a big part of it too and a big help. I was ten years older than Skeeter, but he followed in my footsteps. When we got the opportunity to get all the equipment off of everybody, from various family members, it was mostly him and I that always did it together. He was a big part of this. Then, my son got older and we got him involved and then my grandsons. We have a lot of fun. You get to see relatives you don't get to see outside of summer. That's the important thing to me. It's work—it's not all that easy, but it's a tradition and it's our family's thing."

BEHIND THE BUTCHER'S DOORS

Talking Scrapple-Making with Small-Town Butcher Shops

Just off Interstate 78 in Berks County, in the idyllic farmland town of Krumsville, Pennsylvania, you'll discover the queen of Pennsylvania Dutch meat, Verna Dietrich, the family matriarch of Dietrich's Meats and Country Store. Her family's half-century-old artisanal butchering business is respected nationally for its naturally processed meats.

But as for Verna herself, her life has been butchering. Raised on a dairy farm nine miles away in Virginville, she attributes to her grandmother many of her ninety-some original German American meat recipes that she stocks today. (Be warned: she's charmingly protective of her family's trade secrets and recipes.) She extended her appreciation for raising natural animals to her own family, who with extended families continue to help run Dietrich's business.

You won't find many butchers anymore who raise, slaughter and process their own beef, lamb, rabbits and pork. But Dietrich's does. The meat is right off the farm. It's that level of commitment and dedication to the craft of butchering and Verna's appreciation for fresh, local food that allows Dietrich's to continue to be a shining example of quality Pennsylvania Dutch meat inspired by traditional, old-world practices.

Step inside their country store and you'll be bombarded with a wonderland of every last cut—from common to unusual, links upon links of fresh sausages, leaf lard and endless cold cuts, including Dietrich's renowned Lebanon bologna. You can even spy the meat-cutting and sausage-making room behind glass, behind the shop's counter. They celebrate snout-to-tail in

all its glory. Taking home pork brains and sweetbreads? No problem. Want to stock up on oxtail, hearts, tongues and kidneys? You betcha.

There are also jars upon jars of pickled exotica, a staple for Dietrich's, which many have experienced via samples at the annual Kutztown Folk Festival. From chow-chow and sauerkraut to crabapple jelly, pickled beets, beans, pig snouts, lamb tongues and guinea hearts, the wondrous world of peculiar Pennsylvania Dutch snacking awaits.

But what many Pennsylvanians—especially former Pennsylvanians—ache for most is Dietrich's original scrapple, which is an excessively porky delight loaded expertly with coriander. It has made its way to Alaska and the West Coast.

The inner workings of how Dietrich's makes scrapple involves a full day's work. Verna's sons and grandsons pitch in to lead the cause behind the scenes at their butchering facility, which dates back to 1975. Stainless steel vats are piled with five hundred pounds of pork and beef bones that remain from the week's slaughter, with heat quickly filling the room to a point that it is as steamy as a sauna. This will boil for at least four hours, with a third vat stewing as well with liver and skin. (Years ago, Dietrich's would stew scrapple in a cast-iron cauldron over a wood fire, but due to government regulations, it had to modify the process.)

Like those making scrapple on family farms, the cooked bones are spread out in pans to cool. Then, five or so employees circle the bone carts, handpicking every last bit of meat for the batch. It takes about an hour for them to collect the meat, which is soon ground in a behemoth of an industrial grinder, affectionately called "Butcher Boy."

This results in roughly three hundred pounds of ground meat, plus ground liver and fat from the secondary vat, returned to the stainless steel where it all began. Twenty pounds of ground pepper, salt and ground coriander are added to the boiling-hot meat porridge, with additional shakes added here or there with ground flour and buckwheat over the course of a few hours, to taste.

Dietrich's believes that scrapple is a true "slow food," never a rush job at any point in the process. It's allowed to mature into the textbook-perfect product from one batch to the next, requiring more than twenty-four hours to produce and a handful of staff members to make it across the finish line. After a few expertly tongued employees approve of the batch via a finger-licking taste test, the porky mush is ready to be poured into five-and-a-half-pound containers and chilled overnight in a thirty-four-degree refrigerator.

It's Dietrich's way of life, to respect the traditions of its heritage and continue to share it with others. Scrapple isn't the only age-old traditional meat it processes for shoppers either. While you stock up on your blocks of house-made scrapple, you can also grab head cheese, souse, tripe, crock and liver pudding and veal pate. In addition to Verna's country store, she also continues to have a stand at Renninger's Farmers' Market in Kutztown, Pennsylvania—which is where she started nearly sixty years ago—and makes memorable annual appearances at her pop-up butcher shop at the Kutztown Folk Festival.

Stoltzfus Meats

Similarly to Dietrich's Meats, Stoltzfus Meats is a family affair and started out of a small stand in a country market. Myron Stoltzfus's father, Amos, of Lancaster County, Pennsylvania, was born into a family of twelve on a sustainable farm. Raised to do everything themselves—including butchering—the family would "dress" chickens and pigs on the farm and take them to be sold. They'd travel as far as Philadelphia to sell their meat to help support the family during the years of the Depression.

As Myron recalled, in 1954, his father became connected with New Castle Farmers Market in New Castle, Delaware, and would travel an hour to sell his products on Fridays and Saturdays. "There were scores of farmers' markets in the '50s, and my dad was one of the pioneers of that," he said.

At first, though, he didn't do very well. "He took my mom along, for moral support," Myron continued. "The owner didn't want to accept that he was leaving. So, my dad looked at my mom and she said, 'Well, why don't we try for a couple weeks yet?' So, he did. The next week he made a little money and the rest is history."

As the demand increased for local, quality products, Amos started making and selling his own items. "At first, he wasn't doing his own slaughtering and butchering of his own animals," recalled his son. "But what it did was require the need for that."

In the late 1950s, Amos's father sold him a few acres on the farm, and his brother helped him construct a butchering building. Then he hired his brother-in-law, and they worked together for a few years. "I doubt he was that skilled at butchering at the start, but his successes came with a lot of trial

and error," continued Myron. "He had beef, hogs and chicken on his farm and eventually created the need for custom butchering."

The New Castle market stand continued to prosper, triggering the need to supply customers with more opportunities for Stoltzfus Meats. In 1966, Amos opened a retail location in Intercourse, Pennsylvania, that, come 2009, still saw demand for expansion. That's when, led by Amos's son, Myron, they relocated the business to the heart of the town, across the street from the touristy Kitchen Kettle Village, and opened a new retail store and restaurant, Amos' Place Restaurant, with expansive seating.

Everything about Stoltzfus Meats' success blossomed out of Amos's love for cooking and creating culinary delights. His biggest successes were found within in the products he produced that carried on the tradition of processing a wide variety of fresh and smoked meat products. Amos and his family have received endless praise and critical nods for their old-fashioned sweet bologna and smoked ring bologna, fresh country sausage and ham loaf, sausage grillers (eleven different flavors), smoked turkey, kielbasa, dried beef and kettle-cooked scrapple.

For Stoltzfus's Pennsylvania Dutch scrapple, in particular, it comes from a recipe that Amos used to make on the farm, as they desired to not waste anything when they'd butcher a pig. "They'd keep the liver, the kidneys and the skin. They'd boil it with flour and cornmeal and make meat porridge because it was a very inexpensive way to feed a family of twelve."

In the old days, it was seen as a "catch all." Today, Stoltzfus Meats is pretty selective with what it puts in its recipe. For example, you won't find kidneys in it. It continues to produce it the old-fashioned way, by kettle-cooking with the same kettles used for three generations, and if anything, the equipment is the only thing that has changed through the years. "I had a one-hundred-pound grinder and now I have a thousand-pound grinder, but our process is still the same—it's just bigger," said Myron. He also, rather religiously, still uses a wood-fired process to take advantage of all-natural smoke. "You can't replace *real* smoke." Chicory and apple woods attribute to their scrapple's overall flavor.

Additionally, it has used the same cornmeal from Haldeman Mills for decades. Myron's elementary school friend Richard Landis even bought the mill business in recent future. "Scrapple is not created equally," continued Myron. "There are various ratios of flours and cornmeal and all the other ingredients you put in scrapple. Because of those variants, there are various outcomes. I am very partial to ours and very few others."

A Delectable History

Stoltzfus Meats at one time adventurously made a maple scrapple. Myron said that they didn't quite make enough to make it worth their while, but they may try it again. "Not sure you could make scrapple that would be successful with different flavors. It just isn't scrapple anymore."

Although Myron is aware that scrapple gets a bad rap, more people are eating and buying scrapple than ever. "We make more and more scrapple, and people—young people, in particular—love it. It's almost a hipster food! You would've thought in my dad's generation that 'older people' were the ones eating more scrapple….Honestly in my business career, I've asked myself, I wonder if scrapple is going to burn out, be one of those products that eventually the young people won't eat."

An example of a traditional meat that slowly has fallen from the limelight is souse. "Young people don't eat that," he said. "It had a little bit of a renaissance, but really pretty small. That isn't something that survived. I knew businesses that made souse, and they aren't around anymore. People who have made it, their sales have dwindled."

But for scrapple, it's held its controversial place in the marketplace without fail. "I think people think you put a bunch of junk in it, and it's not the case. It's a natural product made with wholesome ingredients. Plus, if you eat scrapple for breakfast—that's a hearty breakfast. It's like eating oatmeal, you're good for the day; good until dinner."

At Stoltzfus Meats, its mission, like scrapple, is embedded in tradition and fresh ingredients and seasonings. Freshness is always key. Myron added:

> *When I look back at his timeline and when my dad did things, he was pretty bullish, pretty courageous. He was very progressive….As history went on, people didn't live on farms anymore. Or they did, but they didn't want mess with slaughtering animals. It's a lot of work—so they'd hire a butcher to do it. And that was Stoltzfus Meats.* [It performed custom butchering up until fifteen to twenty years ago, but due to regulations, it decided to focus only on butchering for retail purposes.] *If you are able to penetrate someone's memory through the food you make and your products, that's something special. Folks may not remember my name, but they remember I'm the guy with the scrapple!*

Hatville Deli

For the Esh family of Hatville in Lancaster County, Pennsylvania, they've been dedicated to growing and producing quality foods for more than forty years. In the early '80s, the family opened Hatville Deli at the Reading Terminal Market in Philadelphia in order to meet the growing demands of travelers, conventioneers and the local community. Now, as of 2017, the business is run by its second generation, Ann Michelle (Esh) and her husband, Jason Stoltzfus.

"My father-in-law, Samuel Esh, was one of the original Reading Terminal Market vendors—through the remodel and all," said Jason. "My wife and I have been coming to help with the business for the last five to six years. My wife practically grew up here. She could barely see over the counter when her dad started the business."

Through the years, a substantial part of the Hatville's market stand was selling scrapple to hungry purists—in addition to corned beef specials, of course. The secret of their scrapple stock is that while they don't make it themselves, they are loyal to stocking the homemade supply from a small company in Chatham, Pennsylvania, called Frank's Country Scrapple. "[Frank's] is just a little hole in the wall—you wouldn't even know it's a butcher shop. They don't even butcher, but they do make their own scrapple. It is made from various parts of the pig, and it is meatier than some."

For the record, Jason swears that the meatier scrapple recipes are usually the better ones. As for Frank's, it has a lot of meat in its version. (Frank's Country Scrapple has been produced for decades and is most popular in Lancaster, Pennsylvania.) Regular customers come back every week for it and say, "It's really good!" Even for Jason, since he started eating Frank's, he can't eat any other scrapple.

Hatville Deli continues to have customers visit its butcher case and experience scrapple for the first time. "You don't have to go too far west to not see scrapple," he continued. About a year ago, the business even started shipping its products, and scrapple is its top item to ship, shipping out weekly. It has since developed customers all over the United States, especially around the holidays, including a frequent online shopper who is a Lancaster expat now living in New Mexico. "She wasn't able to get it anywhere."

Want to find a respectable butcher shop near you that remains rooted in Pennsylvania Dutch traditions and serves product of the utmost quality?

Here are additional food pioneers who sling their own original scrapple products.

Groff's Meats, of Elizabethtown, is worth the visit for the sheer fact that it has been in business for more than 140 years, and its scrapple recipe hasn't changed much through the decades. It's heavy on the spice, allowing it to be more fragrant in its aroma and taste.

Martin's Custom Butchering, of New Holland, is located in the heart of Amish country, so expect to be sharing the roadways with more horse-and-buggies than cars. This butcher crafts scrapple with both pork and beef, so expect a heartier, more filling experience with this scrapple. I can predict you will be able to notice the beef additions, but if you're a red meat appreciator, this may become your gateway scrapple.

The Meat Hook, of the Williamsburg neighborhood of Brooklyn, New York, may not possess burly fifty-something men who have been hauling around animal carcasses for the better parts of their lives. But something must be said for the new-wave, nine-year-old shop that came out of the gate making its own scrapple. Sure, it's reinvented: it mixes in rye flour with the cornmeal and buckwheat, and there more seasoning, like black and white pepper, clove, allspice, coriander, nutmeg, sage, marjoram and chili powder. But the super-hip butchers show intense bravado in processing good meat raised humanely on farms like the olden days, and that sort of manifesto is what could make scrapple *sexy* again.

S. Clyde Weaver, with a retail store in East Petersburg and multiple stands in Lancaster and beyond farmers' markets, has operated since 1920. It mixes wheat flour with cornmeal with seasoned pork to create a memorable scrapple rendition. Without any doubt, it recommends that you enjoy it pan-fried with syrup and/or apple butter.

Stohler's Meat Market, of Schaefferstown, right on the dividing line of Lebanon and Lancaster Counties, may not make fresh scrapple all year—it halts production between Memorial Day and Labor Day—but it'll sell you some out of the freezer during those summer months if you ask nicely. Its products are said to be the "porkiest" around and available at four dollars a pan.

Zimmerman's Butcher Shop, of Lititz (seemingly closer to Lincoln), is a step back in time. Don't expect a storefront or a sign or, really, even to know where you are going. But its sweeter product is worth trying, especially because it's made with a splash of maple syrup.

WHOLE-ANIMAL BUTCHERY MADE SCRAPPLE *NEW* AGAIN

In 2014, acclaimed food writer Josh Ozersky penned an essay for *Esquire* magazine reasoning with any food-loving soul who had a heart that scrapple should be considered one of America's most crucial meats. He was incredibly self-aware, pitching his plea from the start that "like none of you, I am a big fan of scrapple." But his scrapple love wasn't just backed by his undying passion for the porky loaf. He also made several valid points!

"Loving scrapple means loving pork," he wrote. "Everybody love bacon—but that doesn't give you lardcore status. Neither does gobbling down confit pork belly or spare ribs....It's how you feel about the offal, the nasty bits, the lard and the liver, where you separate the men from the boys."

With that, he went on to wax poetic that scrapple is a true testament to American past and it has changed very little along the way. It's a regional treat and an ancient cousin to sausage and requires the most from its cook. (And if you're a cook yourself, you love that!)

This popularized article dropped during the height of the reemergence of whole-animal butchery. Cultural magazines like *Brooklyn* picked up his article, harping to anyone who would make an effort to click on its link that perhaps "we should all start eating scrapple now!?" (The answer is yes, always yes!)

But let's be clear: the nose-to-tail culinary movement did help scrapple become less of an ugly stepchild and more the cool older brother you

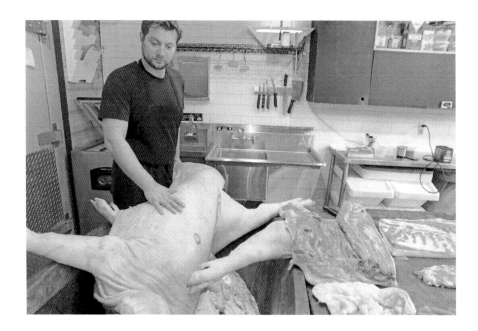

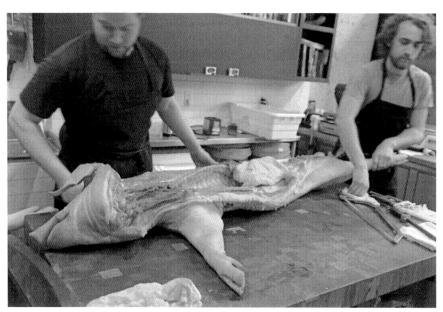

Butchering day at Kensington Quarters, Philadelphia, Pennsylvania. *Amy Strauss.*

just wanted to be seen in public with. Starting slowly, in 2012 and at its extreme heyday through 2014, chefs from coast to coast would blanket their menus with sweetbreads and kidney, heart and tripe. Foodies would book whole-animal tastings months in advance for their chance to argue over who'd call dibs over the pig's brains. Scrapple was standing on the sidelines rejoicing that finally, in the food-crazed society of the twenty-first century, people—especially in urban settings—actually appreciated things like offal-loaded slabs of meat.

There was a time when the idea of eating a whole animal, from its nose to its tail, was not a food trend. It was just being thrifty. It was living by the frugal "waste not" mentality and making use of every last scrap of the animal that you raised on your farm to provide substance for your family. This was the mindset that bred the popularity of scrapple through centuries and helped establish it as an affordable menu mainstay on endless East Coast breakfast menus.

When nose-to-tail dining became in vogue and "cool" for rising chefs to waste virtually no part of an animal in their restaurant, we Pennsylvania Dutch folks rejoiced! Our culture has been doing this all along, but now it was a trend that challenged the most creative chefs to make use of the elements of the whole animals they were bringing into their restaurants. Chefs taking on the task of butchering in house became the norm, too, changing the landscape for what diners would expect on breakfast, lunch and dinner menus.

In 2014, chef Damon Menapace led the whole-animal crusade in Philadelphia's Fishtown neighborhood under the aegis of Michael and Jeniphur Pasquarello's latest concept, a restaurant mashed with a butcher shop and culinary classroom named Kensington Quarters. The concept's underlying goal from the get-go was to support local agriculture and products—more specifically, whole animals and properly raised meat. Once the local meat, typically sourced from Stryker Farm—which makes a mean scrapple itself—arrived at the restaurant, the butcher and chef would utilize everything to the most. Together, they would ensure that every bit of every animal was rendered to its best potential; it was up to the skills of the butchers and chefs to turn every last bit into something delicious and exciting.

So, that's what they did. And it worked! You'd walk in off the trendy streets and immediately be able to gawk at the well-stocked butcher case and look within the on-display meat locker where multiple carcasses were just waiting for their tender time with the butchers' knives.

A Delectable History

Sure, other restaurants have supported the nose-to-tail movement, splashing all the bits throughout their high-end menus. But it's rare that anyone latches on to the concept with such bravado. It wasn't executed to slap you in the face with all the raw meat, but more to help locals appreciate where their food is coming from. They followed through with the concept, too, weaving house-made charcuterie, head cheese, terrines and beef heart at times, next to dry-aged pork chops and ribeye, smoked kielbasa and duck breast.

Then came brunch. Chef Menapace joined the Kensington Quarters team from the start, coming from a now-defunct pig-centric restaurant, Cochon. There he'd made scrapple from scratch as a brunch special. At his butcher shop/restaurant, though, he was getting one to two pigs a week, and there were a lot of extra parts. Enter scrapple. "Having a surplus of scrapple is an easy outlet," he said. "People in Philly like scrapple—and we do a pretty big brunch. It just makes sense that we make it." The restaurant tends to make a fresh batch every week to every other week, depending on the demand. "I don't want it sitting around too long. I like to keep it fresh."

He suggests that their recipe is pretty traditional. He's a Chester County, Pennsylvania expat, so he's enjoyed scrapple since he was a kid. He's keen in

Chef Damon Menapace of Kensington Quarters, Philadelphia, preparing a twenty-pound batch of scrapple for the restaurant. *Amy Strauss.*

Pennsylvania Scrapple

Kensington Quarters' twenty-pound batch of scrapple, ready to be chilled for brunch service. *Amy Strauss.*

believing that scrapple's longevity is due to "community traditions. In other areas, no one has ever heard of it. I'm sure they make something along the same lines to use animal parts up, but I just imagine it's the culture around here that has kept it alive."

He does suggest that the big debate around the Greater Philadelphia area is pork roll or scrapple. "If you're someone from South Jersey, you're more affectionate to the pork roll. West of the city toward Lancaster, people are more loyal to scrapple." (Kensington Quarters does not make its own pork roll.) For Kensington Quarters' scrapple, it mainly uses the head and some other pig parts. "People always think when you start talking about using the head that you're using brains and eyes—we're not. Most of the head is skin, fat, lots of meat in the jowl, cheeks and even behind the ears is a good bit of meat. We don't use the eyeballs, the snout or the brain."

Generally speaking, Menapace explained his scrapple-making process: "We use the fattier parts of the pig with some meat, a good bit of skin and cook it all down until it's really soft, grind it, thicken it with cornmeal and the liquid that we cooked the pig in, and we season it with breakfast flavors—sage, maple syrup, black pepper."

A Delectable History

The scrapple-making process itself extends multiple days. Prior to grinding the pork meat, the on-site butchers soak the pork in a saltwater brine with fresh herbs for four days. This enables the meat to soak up a good deal of salt and the flavors of the herbs. The brine-soaked pork is roasted "super slow and for a really long cook" overnight with very little water. "In the morning, I come in and the meat is super tender," continued the chef. "We shred it apart, throw out the bones, the teeth, and pick through it to make sure we have the right ratio of skin-meat-fat. We take that, grind it through a meat grinder. Then we weigh it. We want equal parts of that weight, plus the liquid in the pan (that water gets super sticky from all the gelatin, connective tissue, ligaments and fibers, and that all melts into that liquid—it is really jello-y)."

Chef Damon swears by—almost scientifically—the ratios of ingredients in order to create the perfect end result. "Our recipe is equal parts ground meat and liquid, and 15 percent of that total weight is how much cornmeal we use. It's very mathematical. It comes out the same every time."

That 15 percent of cornmeal is exclusively from Castle Valley Mill in Bucks County. "Castle Valley is all non-GMO grains, so you can feel good about it being grown by someone local who isn't spraying the crap out of their crops. They are good people and came in when we first opened. We wanted to get as many local producers as possible."

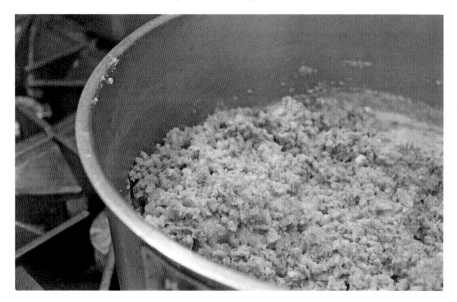

Ground pork ready to become scrapple at Kensington Quarters. *Amy Strauss.*

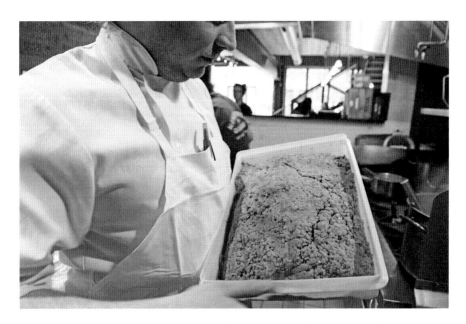

House-ground pork ready to become scrapple at Kensington Quarters. *Amy Strauss.*

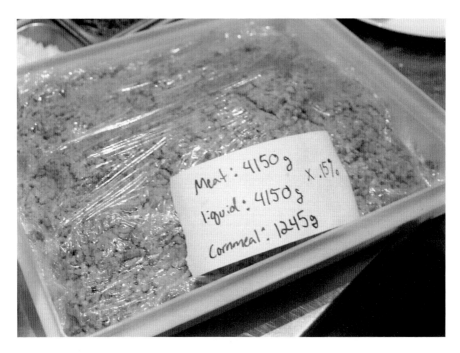

The secret to Kensington Quarters of Philadelphia's success is a perfect ratio of meat to broth and cornmeal. *Amy Strauss.*

A Delectable History

Traditionally, scrapple was made with buckwheat flour, although this chef is calling the shots and he doesn't care much for buckwheat. "It has a dusty flavor," he said. His technique when making scrapple all lies in cooking the cornmeal in first. "We used to make it where we'd add cornmeal with the meat and liquid already mixed together, but it's so thick by that time that it was so hard for the cornmeal to cook. Cooking with the liquid first gives it its binding property. The resulting gelatin from using the head and skin in the recipe does, as well. But the cornmeal is the most essential. You want to make sure you get that cooking for some time, and be warned, it's like hot lava that shoots everywhere."

Damon allows the cornmeal/liquid mixture to cook until it's just right (i.e., not gritty), and sometimes he has to cook it longer to fully hydrate the mixture. Then he adds in the ground meat, with the perfect ratio of meat stitched among little bits of skin and fat. "We sort through it before we grind it to ensure that it's not too fatty. If there is too much fat, it won't bind up either. If that happens, we get to Sunday morning [brunch service] and we drop scrapple in the fryer, and it just falls apart. We've gotten better; we've gotten skilled and learned what makes it happen."

Eventually, he mixes the meat into the cornmeal/liquid mixture until it is well balanced and resembles a "hot meat porridge." He and his sous chefs do a taste test and add in extra seasoning or extra sage "for good measure," if necessary.

When ready, the twenty-pound batch of grayish gruel is poured into plastic wrap–lined pans. "What we are looking for is if it tastes right and looks right. Ideally, we refrigerate it overnight until it resembles bricks."

Kensington Quarters sells its scrapple at brunch and has occasionally weaved it into some interesting dinner options. It sells it by the six-dollar slice, each quarter-pound slab fried to order. Chef Damon devised a Scrapple French Toast as of 2016, and it has yet to budge from the menu. "We put a piece of French toast on the grill—needs to be a hardy bread. Then we douse it with maple syrup, put a piece of scrapple on top, put a fried egg on top of that, and then we put sage and brown butter and drop that over the top. It's a perfect sweet-and-savory brunch combo."

Recently, as of late 2016, the restaurant made the transition of removing its in-house butcher shop with stocked meat case in favor of additional restaurant seats. The butchering corner and meat locker are still very much in use. How about dinner and a butchering show? "It allows us to focus on the cool stuff—like making scrapple. We can bring in less animals, too, and we were getting a little overburdened."

WHAT'S FOR BREAKFAST

How to Eat and Prepare Scrapple

Let's be real: scrapple, as it is cut from its loaf, is an unappetizing, gray-hued hunk of congealed meat. There is no denying that. Once fried in a sizzling cast-iron pan, it is dark-golden brown and worthy of your adoration. Any number of toppings can—and should—be slathered, smeared or sandwiched with your share of the iconic delight.

There's a thirtysomething living in Toronto, Canada, Adam Gerard—you'll learn more about him later—who is somewhat of a scrapple expert and advocate, managing the scrapple blog *What's Scrapple?*. Prior to blogging, he started a Facebook page (search "scrapple" and you'll find it) that quickly received more than fourteen thousand followers. He knew then he was not alone in his scrapple obsession. "It's been interesting and a long learning process of wading through strong opinions of scrapple on my Facebook page," laughed Gerard. "A lot of people are opinionated about how to eat it and which brands they eat."

Let me stop there. In case you didn't know it was possible, the *way* you eat this congealed meat is very controversial. Every scrapple eater has a specific way they like it prepared, from pan-frying it with butter to deep-frying it until extra crispy or even baking it for "healthier reasons" (come on, you are eating scrapple). But there are also so many ways to cook it the "wrong way," and if you're caught, someone will beat down your door and throw hasty sacrilegious comments your way. (You've been warned.)

So, rather than tell you the "proper" way to prepare and eat scrapple, I underwent a thorough investigation to see what ways are most common

A Delectable History

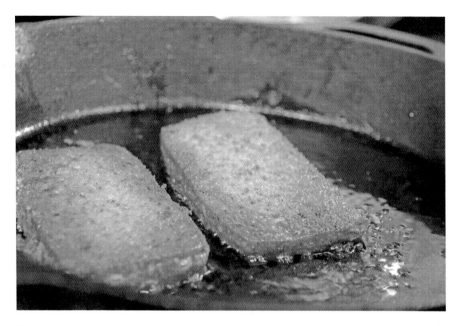

Slices of scrapple crisping in the cast-iron skillet. *Amy Strauss.*

and perhaps even a bit newfangled and revolutionary to the wholesome world of scrapple.

Like Adam, I started on Facebook with a survey. In a matter of one hour on a wintry January Saturday, I received seventy-one comments regarding how one likes to cook his or her scrapple. I targeted the epicenter of those bred in the Pennsylvania Dutch culture (in the Greater Philadelphia region) to share what cooking habits were most traditional to them, as well as how they have taken a more peculiar and, at times, curious approach to sizzling up your share of the classic meat.

Joe Ulrich, a Philadelphia resident, sticks to the following process: "Fried in a pan with butter. Then, fry two eggs sunny-side up or over easy in same pan. Hmm, scrapple and eggs over waffles, pancakes, or in crusty bread as a sandwich with hot sauce and a drip of honey—salty, buttery, sweet and spicy."

Sliced thin, with butter cascading around the sizzling pan, amounted to the most popular method, with some alternating butter for oil, vegetable shortening and, the most traditional, lard. Rob Hughes, who grew up on a Chester County farm, said that the usage of lard is "the only way!"

Dan Cellucci, chef and owner of the Roots Café in West Chester, Pennsylvania, elevated the flavor experience by dropping in globs of duck or

bacon fat into warm pan. "I save it all, so I have jars in my kitchen," he said. "And, it has to be a cast-iron skillet."

For Melody Dunn, who grew up in Berks County, Pennsylvania, she goes for the straightforward approach. "I just throw it in a pan and fry...no need for butter since it's already fatty."

Kathleen Dandy brings up the act of brushing it with a flour before frying, dredging it with a little cornstarch before pan- or skillet-searing it. (Her bonus tip was to layer it on a pumpernickel bagel and add a slice of cheese for one heck of a sandwich.) Other folks had shared that a quick dusting of white or wheat flour also does the trick to step up the crunchy exterior when searing in a pan.

Then it started to get out-of-the-box, this-is-exceptional crazy. Angela Corrado of Kutztown, Pennsylvania, shared the ways her Pennsylvania Dutch–born and raised mother has inventively approached scrapple through the years. "My mom shaved it really thin once and made what we deemed 'Scrapple Chips,'—trademarked," she joked. "That was probably my favorite. Make a dip with maple syrup as the base and thank me later."

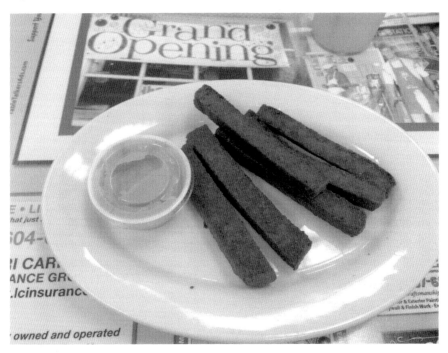

Coffee Station of Morton, Pennsylvania, features crispy scrapple fries for breakfast served with Sriracha ketchup. *Scott McCauley.*

A Delectable History

Is mustard or ketchup your go-to scrapple condiment? How about a little of both! *Amy Strauss.*

Victoria Hoffman of New York City (and formerly Berks County) enjoys it baked on a cooking stone until the outside is crispy, serving with Bauman's Apple Butter. ("Yes, it MUST be Bauman's," she said firmly.) Tabitha Fronheiser opts for the baking approach, too, putting it on a sprayed cookie sheet in the oven at 375 degrees until crispy. She flips the slices a few times to ensure that all the edges are crisped to full potential.

A modernized take on scrapple is scrapple fries, which have seen their fair share of restaurant play in recent year, including the introduction at the Coffee Station in Morton, Pennsylvania. "Imagine all the crispy edges," said Ed Williams of Chester County. (Deep-frying overall was not popular, with Jim Berman, a Delaware-based chef, expressing that "slay thine neighbor that deep fries!")

Then you get into condiments. Ketchup, maple syrup, yellow mustard, King's Syrup, apple butter, mayo (including Miracle Whip exclusively), hot sauce, horseradish, the yolk from poached eggs, grape and/or pepper jelly…the list goes on.

And then there are the brands! People swear that Habbersett is better than Rapa, Kunzler is step above Leidy's, Godshall's beats out Hatfield, Dietrich's is tastier than Frank's Country Scrapple and…my head is

spinning. Most agree that whatever the brand, it must be cooked slowly in a greased heavy pan (cast-iron is most preferred) over low heat and not flipped until you see the distinctive crust blossoming from the edge touching the pan. There's still no consensus as to whether slicing it thin or thick, dredging it in flour or not and frequent flipping in the pan with a spatula or leaving it undisturbed does the trick.

But there's always *someone*, like Wisconsin-raised Susan Maloney, who confessed that she was "lucky enough to grow up in a scrapple-free world." Lucky?! Maybe "deprived."

Whatever the technique, where are you going to begin? What method do you think takes the title?

SHORT ORDER

Classic Restaurants Make Scrapple a Permanent Staple

When I think of a quality diner, I think of my grandmother Naomi—God rest her soul. She was always reliable and especially dependable in case of an emergency. She had a long-standing reputation in her local small town and was scrappy—she could throw one hell of a punch. Most importantly, she could cook breakfast staples perfectly *every single time*.

When I dug deep into the diner culture of the Greater Philadelphia area, a region that possesses a strong Pennsylvania Dutch community that's stuck in its ways and stayed regionally in the areas where they first arrived, one thing was certain: the iconic diner is deliciously dependable and, without fail, serves scrapple crisped in all the right ways.

If in Philadelphia or its surrounding suburbs, I give you a challenge. Visit five diners in a month and find one that doesn't serve scrapple. Frequent Melrose Diner west of Broad Street, Midtown Diner on Chestnut, M&M on Allegheny Avenue, Spring Garden Diner on North Fifth Street or Mercer Café on Westmoreland Street. You won't be able to find one, but if you do, cast shame on them and order it. Or try.

Down Home Diner

Scrapple is a diner legend, and they'd be shunned if they discontinued if from their menu. Jason McDavid, general manager of Down Home Diner in the Reading Terminal Market, attributes scrapple's long-term popularity

Pennsylvania Scrapple

A classic scrapple breakfast with scrambled eggs. *Amy Strauss.*

to the traditionalism of it. "I think Pennsylvania is traditional in itself," he said. "I think we are a state that is a little slower to change—especially when it comes to the Pennsylvania Dutch, who haven't dispersed like other groups have. So, their food culture stays alive and well because those recipes and traditions have been passed down, from generation to generation."

McDavid's father, Jack, introduced his farmhouse-style, retro-cool Down Home Diner to the city of Philadelphia in 1987. After working in many high-end restaurants, from Virginia to Washington, D.C., he landed in the City of Brotherly Love. He banked himself some serious pedigree by landing a gig at the lofty Le Bec Fin, leaving a big impact on menu creation and how Georges Perrier's kitchen was run. Eventually, he dreamed of a place of his own, and that is where Down Home Diner came in.

"It was so different than where he was working," said his son. "They were highly technical, largely complex kitchens where you're cooking for a few customers a night. It wasn't like this sort of business, where it was mostly turnover and you are serving people quickly."

When Jack was opening his first restaurant, he asked himself, "What is it that he really wants to cook for people?" Fine French cooking or the stuff he grew up eating? That's why he planted biscuits and gravy on the menu, made

everything from scratch and weaved in regional staples—like scrapple—of things he adopted from living in Philadelphia.

As McDavid's career grew as a restaurateur (he opened Jack's Firehouse a few years later), he and Bobby Flay did a show on the Food Network called *Grillin' and Chillin'*. "It was Bobby and my father's debut on the national stage, and obviously, Bobby went on to do great things, and my father focused on his restaurants," said Jason. However, McDavid has received his fair share of press, including a "Best Chef in America" nod from *Food & Wine* magazine in 1991, among others.

Now, after thirty-one years in business, Down Home Diner remains committed to sourcing things locally and making them from scratch. "We've been doing that for years, and it isn't because it's popular to do now. We've been doing that forever," said Jason, who recollects that one of Down Home's first press mentions was about how they made mashed potatoes from scratch. "Though that sounds like a funny thing now, back in the '80s people were making instant mashed potatoes in every restaurant in Philadelphia. It's crazy!"

Down Home Diner doesn't cut corners or open cans. It provides fresh, made-from-scratch ingredients, and a lot of the time those ingredients are coming

Down Home Diner in the Reading Terminal Market, Philadelphia. *Amy Strauss.*

from in the Reading Terminal Market. The diner's scrapple is also sourced from within the market, from L. Halteman's butcher shop. (Halteman's also supplies Molly Malloy's, another RTM vendor, with its pork scrapple.) "We really do have that commitment to sourcing things as locally as we can," Jason continued, "and their [scrapple] comes from Lancaster and it's a good, reliable product."

Scrapple is one of those things that has always been on the menu in some way or another just because it's novel to the southeast Pennsylvania area. McDavid confidently shared that Down Home Diner's poached eggs and scrapple is always on the menu and will always be on the menu.

Its Lancaster scrapple is sliced thin, about one-fourth of an inch, and prepared on the flat-top grill until it's delicately crispy on the outside and creamy on the inside. It's big enough to encompass the whole plate, crowned with two textbook-perfect poached eggs and a side of melon. "I always tell customers: get it with eggs or get it with syrup," he laughed.

McDavid admitted that he still encounters new employees who are unfamiliar with the Pennsylvania delicacy. "When I train them to describe scrapple to others, I tell them to 'listen up—this is really important.' We don't call it 'pig parts.' We say it's made the same way you would make sausage except it doesn't have the casing, and they add buckwheat and cornmeal so it has a creamy finish to it."

Jason McDavid, general manager of Down Home Diner of Reading Terminal Market. *Amy Strauss.*

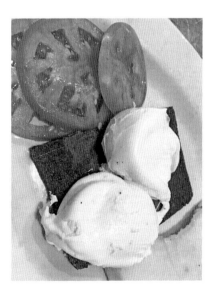

Down Home Diner's permanent menu staple—poached eggs and scrapple. *Amy Strauss.*

Server sporting Down Home Diner's iconic tee. *Amy Strauss.*

And his servers do have to explain scrapple to their customers—even if they are smack-dab in Center City. Jack even had custom restaurant T-shirts designed for the staff, bearing explanations about how scrapple is made, "where are the 'scraps'" and the origins of the breakfast wunderkind, as well as noting that you should simply "eat more scrapple." He even concluded the wordy tee with one bold line: "In one form or another, scrapple has been served for hundreds of years in Europe and throughout the United States—but no place makes better scrapple than Philadelphia."

Server Brendon Chhan said that scrapple is definitely one of those things you'd have to explain to someone coming from out of town. "When customers try scrapple for the first time, they are usually very surprised by it. What I've found is, sure, we have the regulars coming in for it, but we also have international people coming in that have to try it with mixed results….The taste is much different from any other pork product. It's better, it's crispier, it's tender on the inside. It's just great!"

"We always make sure there is a scrapple dish on our menu. In our minds, it is not a side—it is what makes the dish," continued Jason. Others must agree with Down Home Diner because scrapple is its top-selling breakfast meat, selling at minimum one hundred pounds of scrapple per week.

Dutch Eating Place

Jaden Esh has a similar story to those of the Down Home Diner. In partnership with his father, Samuel, know as "Junior," they run the Dutch

Eating Place restaurant in the Reading Terminal Market. As one of the popular places to eat in the market, Dutch Eating Place specializes in classic Pennsylvania Dutch breakfasts and lunches—and it most definitely plows through quite a few orders of scrapple each and every day.

It was over twenty-five years ago that Junior, an Amish man, traveled every day from his Lancaster farm to run his traditional lunch counter. His son, who grew up doing the same ("it's all he knows"), suggested that his father launch this restaurant concept at the Reading Terminal because of their heritage. "It's traditional; it's what we eat at home," he said. "We serve very traditional Amish meals—everything on menu is inspired by our heritage."

The Eshes have grown up Pennsylvania Dutch and are Mennonite. Junior's father grew up Amish, with his parents remaining old-order Amish—yes, they drive the horse and buggy and they don't have electric anything.

When the restaurant first opened, Junior's parents had their own butcher shop, so he served exclusively his family's scrapple. When they sold their butcher shop, the Eshes found a comparable product from another company in Lancaster, Leidy's. Now, the rest is history. They continue to pound out hearty morning-starters day after day. At least 50 percent of the customers flock into the restaurant for inch-thick slabs of fried scrapple, some of which coming to try it for the first time. The newbies' initial responses are a mixed bag, Jaden suggests, from most people really liking it and others not really sure what to think of it.

But although he's a maple syrup guy—that's how he and his family always ate it—he sees a lot of diners smothering their fair share of scrapple in ketchup. But if you are one of those ketchup-obsessed eaters, here's a request: if you order his top recommendation—blueberry pancakes with a side of scrapple, all of which to be eaten together—follow his lead and be a "syrup guy."

Smucker's Quality Meats & Grill

In August 2009, Moses Smucker introduced his Pennsylvania Dutch hot spot, Smucker's Quality Meats & Grill, to hungry Reading Terminal Market shoppers. The jovial, bearded Dutchman occupies a stall long used by meat sellers, including Charles Giunta's first solo venture in the mid-1980s.

Moses speaks with pride about being among the first merchants to wrestle scrapple into a breakfast sandwich. His popular no. 7—an egg, cheese and scrapple sandwich on a round, airy roll—comes with generous-sized portions of the porky world wonder. It's messy and delicious, and the crispy scrapple slice overflows from the bun.

Beyond the grill, he features a meat counter, too. His fresh selection is limited but excels with his smoked and cured selections (heck of a lot of beef sticks and jerky!) and features products from John F. Martin & Sons. Of course, scrapple leaves its mark among other hand-selected meats, so gobble down your greasy goodness and take some for the road.

In all his years, scrapple has remained a mainstay for his Pennsylvania Dutch business. However, he said that not all traditional meats were able to maintain the popularity scrapple has. He's had to cut puddin' (like scrapple but without the cornmeal) from his product line due to lack of sales.

SHORTY'S SUNFLOWER CAFÉ

In the mid-'90s, George Bieber made a buzz-worthy splash in the Pottstown, Pennsylvania food scene by debuting a local farm-sourced, quality breakfast-and-lunch hub, Shorty's Sunflower Café, that specialized in regional favorites produced with a creative slant. He quickly captivated hungry palates with its interpretations of flavor-packed egg sandwiches, Texas toast eggs in the hole, plate-sized fluffy pancakes (called the Big Original), fresh baked breads—including his notorious zucchini bread—and ongoing, rotating specials that were both cutting-edge and something you couldn't pass up.

One of his first conceptualized dishes, the Flying Dutchman, continues to remain on his menu today, hoisting the celebrated regional favorite—quite literally—on a (bread) pedestal. "The dish was created in the very early days of the cafe," Bieber said. "Call it the summer of 1996. I love dishes with names or titles, and what a more fantastic one than the Flying Dutchman? Since Scooby-Doo and those meddling kids first introduced me to that mysterious craft, the tale of the Dutchman has been one of my favorites.

To illustrate how he dreamed up the concept for his famous scrapple-stacked breakfast dish, he offered a sneak peek into how his brain sometimes works while creating new dishes:

> *I want to create a special dish using scrapple.*
> *"Scrapple" = PA Dutch*
> *"PA Dutch" = Apple Butter*
> *"PA Dutch" = Dutch Man*
> *"Dutchman" = Flying Dutchman*
> *"Flying" = Going to have to stack this dish for presentation—make it fly.*
> *"Breakfast dish" = eggs*

Pennsylvania Scrapple

The final verdict: "Eggs on Scrapple with Apple Butter on Toast—why not wheat?—on home fries. The Flying Dutchman is born!"

Bieber revealed that he always keeps Hatfield Lean Scrapple stocked on the repeat. "Scrapple has always been a side option at the café, and I was surprised how much of it we sold," he continued. "It's second only to bacon in our weekly sales! I better think of something extra special to do with it—it's generally a really good food cost item too."

Neptune Diner

In Lancaster, Pennsylvania, home of the highest concentration of the Pennsylvania Dutch population, the classic, down-and-dirty Neptune Diner is celebrated for its "specialty pork and cornmeal mixture," as Travel Channel's *Food Paradise* described it.

Debuting in 1994, the family-run and family-operated restaurant specializes in good ol' country cookin' right in the heart of Pennsylvania's farmland. The portions are huge, the prices are affordable and the cooking is just like your grandmother would made it. Among apple dumplings sized XXL and sky-high meatloaf stacks smothered with cheese, there's the other kind of meatloaf that keeps the locals coming back for a taste of home.

Co-founder Cus Mountis is something of a grill master at the archetypal American diner, preparing a perfect slice of pork scraps each and every time. He swears by the method of using a grill press to apply weight atop the scrapple to ensure crispiness on every last inch. He uses a spatula to slip underneath the slice when he's ready to flip it, perfecting the cut from the grill's top.

His Scramblers are also a crowd hit. He scrambles up hunks of scrapple with eggs, cheese, onions and home fries to create a simple hometown favorite that's so comforting most folks lick the plate clean.

Honey's Sit 'N Eat

Classic and cozy, Honey's Sit 'N Eat serves Philadelphia with two always-bustling locations in the Center City and Northern Liberties neighborhoods. You may not expect a restaurant that specializes in southern cooking executed with Jewish influences to excel at scrapple to order. But the family-owned

business didn't think twice about making its own scrapple and throwing it on the menu—it is in Philadelphia after all. While you can order a thin-cut slice on the side, the real magic is in the twelve-dollar Breakfast Bomb, which combines everything you ever want at breakfast and stuffs it all into a ridiculously giant, extra-fluffy pancake. I am talking scrapple and scrambled eggs inside a pancake! Have I died and gone to breakfast heaven?

Jerry's Bar

The kitchen at Jerry's Bar, also in Philadelphia's Northern Liberties neighborhood, is led by chef Marshall Green. Formerly, he owned the popular brunch spot Cafe Estelle, but now he's back on the stoves, taking every step he can to make the corner spot's brunch service sing. For starters, he crafts his own scrapple and smokes his own bacon. His porky slices are always cooked to perfection—crispy cloaking on every inch and gooey insides just beckoning you in. Don't hold back—order at least three slices.

Sulimay's

If you don't live in or frequent Philadelphia's Fishtown neighborhood, you've probably never heard of its local diner institution, Sulimay's. On the corner of Berks and Girard Streets, the unassuming, thirty-seven-year-old diner has remained unchanged as its neighborhood has hit gentrification. It is dressed with wood-paneled booths and a Formica counter lined with spinning stools and led by its high-energy owner, Lucretia Sulimay. Through the years, the menu has evolved, moving to more locally sourced and in-season ingredients, but one thing's for certain: scrapple has always been on the menu. She stitched together her menu with options for both "old" and "new" Fishtown residents, weaving from classic biscuits and gravy, pancakes and corned beef hash to the Eggs Bensington (pan-fried scrapple, Cooper Sharp cheese and "dippy" eggs served over white toast with potatoes) and the Pig Heaven, an omelet with fried onions and scrapple. There's also ongoing specials, and on a recent visit, the chef debuted a house-made spicy "whitefish" scrapple served with beefsteak tomatoes. A fun addition to your visit will be the retro Habbersett advertisements framed along the walls—one proclaims, "I've fried them all, Habbersett is the best."

HOW SCRAPPLE BECAME TRENDY

When Adam Gerard was in ninth grade, fourteen years of age, he slept over at a friend's house. He had just moved to Maryland from upstate New York, and upon entering the kitchen on a Saturday morning, his friend's dad, Mr. Moore, was cooking breakfast.

"All I remember was that he was cooking this strange meat," Gerard said, recalling his first encounter with scrapple. "I didn't ask any questions. I just dove right in and thought it was delicious. Before that, I had never heard of it or seen anything like it. I guess I was immediately mildly obsessed at that point. It became almost a joke. I knew how gross people thought it was, and it was like, here is this thing that I really love and not many people know about. I talked about scrapple a lot. I was devoted at first bite."

I guess you could say Jim Werner, a lifelong resident of Philadelphia's Port Richmond neighborhood, talks about scrapple insistently, too, so much so that I had multiple people recommend him for inclusion in a scrapple book. "It also reminds me of my childhood, my grandparents, my grandfather, so there's that element to it," he said. "My grandfather was always cooking it. When we went to the diner, he was always ordering it. It automatically makes me think of him. And I actually like it. If we are going to get breakfast, there's no doubt that I'm going to get scrapple and potatoes. That's just what you get."

His most memorable scrapple experience was when he went to a very high-end pig restaurant in Washington, D.C.—it's actually called The Pig—and it had scrapple on the menu. "They served it as a 'Lancaster scrapple'

A Delectable History

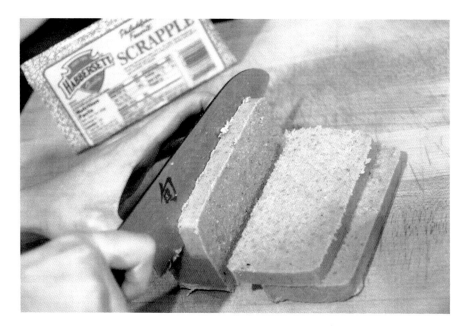

Hunk of scrapple being sliced to fry up for breakfast. *Amy Strauss.*

and the description of it was about the Lancaster, Pennsylvania–sourced pork. I think we paid thirteen dollars for it. I thought, 'This is ridiculous,' but I had to get it because I had to see how they prepared it."

How was the overpriced scrapple? "It was good. It was definitely different than what you'd get at a diner." There's also another restaurant in Washington, D.C., Florida Avenue Grill, that has stuck by serving scrapple since the day it opened in 1944. Current owner Imar Hutchins sticks by the saying, "Why mess with the secret sauce? Where else can you get it today?" Hutchins also serves age-old options like chitterlings and pigs' feet.

Back to Werner. What's even more comical is that Werner works in tourism and has a friend who constantly pitches him a billboard campaign idea to nickname Philadelphia the "Big Scrapple." (Dan, your secret is out!)

Just what about scrapple has caused thousands to flock to online communities to confess their undying affections and take such pride in it? Were they raised in scrapple-eating households and their parents taught them well, to start the day strong with a hearty slab of pork? Or has it remained in the public eye because so many people don't understand it and, in turn, it's remained the object of edible—or to some, inedible—curiosity?

Pennsylvania Scrapple

I tapped Philadelphia chef Adam Diltz, a kitchen crusader notorious for his days at Johnny Brenda's, a hip mainstay restaurant and bar in the city's gentrified neighborhood of Fishtown, to find out. Diltz almost poetically celebrates traditions of the Mid-Atlantic region through his menus, making scrapple in house for his brunch service, and opening a nearby BYOB, Elwood, that is driven by Pennsylvania's culinary roots. "The Mid-Atlantic has tons of history, and I'm going to try to showcase it," Diltz said.

He snarls at giving "hipsters" credit in making scrapple mainstream and attributes its long-term success to its constant place on diner menus. In addition to the dependability of diners in serving the historic dish, passionate chefs like Diltz are adamant about producing "real food" from start to finish, even if, like with scrapple, it becomes a daylong undergoing. "When I lived in Chicago as a sous chef, I gave up everything—my job, my girlfriend—to go be a line cook at Blackberry Farm in Tennessee. I gave up everything to do it 'for real.'"

And now, that's his only way to do it. He's dedicated to producing scrapple the "real," "tried and true" way, even if his current jewel box–sized kitchen offers limited production space. But hey, you can't shortcut scrapple. "Scrapple is a butchering day-thing," he said. "You have a kettle and cook it all day. I make a big batch—and simmer it all night. I'll grind it all up with the liver. I put the scrapple in my little loaf pans and I freeze them. I do a big batch (around sixty pounds), and that covers us for a week to a couple weeks, depending how busy we are."

Diltz has also played with his scrapple composition to keep his diners on his toes. (He is in a gentrified neighborhood, after all.) When the scrapple is still hot, roughly around the stage where you'd pour in into loaf pans, he uses a portion scoop to form the scrapple into balls. He'll freeze these, too, and come brunch service, he'll throw them into the fryer for pure balls of scrapple magic. (Try them with his pepper jelly—sweet, salty and spicy all in one.)

As if his scrapple appreciation could not run any deeper, Diltz has hosted hours-long scrapple workshops at a local nonprofit farm cooperative, Greensgrow, where he has demystified the act of making scrapple from scratch to sold-out classes. (Explore his recipe for yourself within the appendix.)

Like Diltz, chef Cristina Martinez of Mission Taqueria in Center City, Philadelphia, takes the extra steps to craft house-made scrapple for weekly brunch service. But she's not serving slices here. She's crafting it for restaurant-appropriate brunch tortas (it *is* a Mexican restaurant).

A Delectable History

Fried scrapple balls served atop pepper jelly at Johnny Brenda's, Philadelphia. *Amy Strauss.*

The sandwich, with its over-easy eggs and scrapple cushioned between, guarantees a bit of a delicious mess. Add in flavor rockets like chipotle mayo, red onion and tomato and this breezy second-floor taqueria may have just ranked as one of your best scrapple experiences to date.

Perhaps scrapple's biggest moment in the last five years was when celebrity chef Ivan Orkin nurtured it into meeting critical acclaim in 2014. The Jewish chef/restaurateur most notorious for his New York City noodle

The Lancaster Okonomiyaki, built with a scrapple "waffle" as its base, was served on special at Ivan Ramen, New York. *Ivan Ramen.*

shops, Ivan Ramen, muscled scrapple into a waffle iron, enabling it to be tasty, tender and resemble the iconic waffle pockets with all the appropriate crisped edges. It was called the Lancaster Okonomiyaki, with waffled Pennsylvania-sourced scrapple as its base, and topped with ingredients that traditionally bombard the Japanese pancake, including crunchy napa cabbage, pickled apples, bean sprouts and scallions. Two sauces are icing on the scrapple cake: a maple kewpie (Japanese mayo), the Japanese ketchup and mustard, if you may; and the distinct sweet-and-sour Bulldog sauce.

Food critics flocked to Orkin's noodle shop not for the noodles, but for this scrapple-based entrée of intrigue. One writer, Robert Sietsema of *Eater New York*, even deigned the sinful treat to be "a brunch Satan reserves for himself," while the legendary Pete Wells of the *New York Times* dedicated lines to its existence but only to suggest it "hadn't moved past gimmick stage" and would "excite scrapple fans and terrify everybody else." (How rude!)

Nonetheless, the fact that an acclaimed New York City chef decided to tap into the beloved Pennsylvania staple that has roots that stem into the seventeenth century is pretty cool in my book, even if it was a short-term menu offering. "I think that scrapple has an opportunity where it could be more popular in some places," said Adam Gerard when we discussed Ivan Ramen's foray into scrapple paradise. "When you go to nice restaurant that uses local ingredients and it focuses on nose-to-tail practices, scrapple seems to fit right into that idea. I'd expect more restaurants to serve scrapple—not because they grew up with it, but by accident because they are using all of the parts of the animal and scrapple would just turn up in the process."

YOU DID *WHAT* WITH SCRAPPLE?

Even though the term "scrapple" makes its dictionary debut as a "cornmeal mush mixed with pork scraps," it's surprisingly common to find chefs and home cooks alike producing it with another lead protein.

Consider it sacrilegious if you may, but the act of butchering any animal and saving its scraps carries on the classic eighteenth-century Pennsylvania Dutch adage, "Waste not, want not." What else would you do with the scraps other than extend their worth?

CHICKEN SCRAPPLE

Ten years ago, Barry Schwenk and his family made chicken scrapple on his farm. "Everyone was like [saying] to me, 'Why don't try you try to make chicken scrapple? So we did," he said. "I had forty chickens stop laying, so I killed them and threw them in the kettle. We followed the same scrapple-making process with chickens, but you don't have as much fat, so what I had to do was put in a little pork fat so you could get a good flavor out of it."

Would he try it again? "The biggest problem with making chicken scrapple was picking the bones—so many little bones! It took four times longer to pick the bones."

Although more challenging to make a chicken scrapple as opposed to a pork scrapple on the farm, especially if your batch exceeds one hundred

pounds, it's common for chefs to make inventive small-batches—around ten pounds at a time—to fuel their Sunday brunch service or to play with their dinner menus.

In Lewes, Delaware, at the impeccably dressed Heirloom, executive chef Jordan Miller introduced on a recent January night a new dinner plate: the Hen of Sussex, a housemade chicken scrapple layered with poached egg, pepper relish, shaved relish, aged farmhouse cheddar, chicken jus vinaigrette and classic white bread. Maybe my ancestors are rolling over in their graves, but this high-brow reinvention could lend to scrapple remaining front-of-mind for centuries to come.

Heirloom of Lewes, Delaware's dinner special of chicken scrapple. *Heirloom.*

Goat Scrapple

Nearby, at the Rehoboth Beach, Papa Grande's chefs make their own goat scrapple and use it in Mexican dishes like tacos and burritos, while the pacesetting La Fia restaurant in Wilmington takes claim that duck scrapple has carved its place on the menu since the beginning of the eatery's time.

But it's not just swapping out scrapple's pork ingredients that have caused heads to turn. Clever or maybe just crazy (you decide) innovators have taken the classic composition and added it into surprising end results, as well.

Vegan Scrapple

I will not condone eating scrapple without its key ingredient—pork! However, there is a tall tale regarding a South Philadelphia bar and restaurant, Triangle Tavern, and one meat- and dairy-free chef, Mark McKinney.

Although living and working in Philadelphia, McKinney grew up in Delaware. His dad considered scrapple necessary for a proper Mid-Atlantic diet. As part of his upbringing and DNA, though not his current diet, the

chef wanted to bring the iconic meat into his restaurant—all while producing it in a healthier way.

Willing to play culinary mad scientist in the kitchen, Mark played with a recipe of that is not far off from the original Pennsylvania Dutch classic—you know, minus the pig parts. He substituted slow-simmered and pureed mushrooms for the pork scraps and blended in cornmeal and spices. The hot mushroom porridge is poured into traditional loaf pans and chilled until it resembles the grayish classic we seem to love and hate.

For brunch service, you can order a three-dollar slice as a side or as part of an epic, very-vegan twelve-dollar breakfast including tofu scramble, sautéed spinach, vegan Cheez Whiz and fried potatoes.

The vegan scrapple outsells all other brunch options on the menu—including pork scrapple. (Yes, it has that, too.) Although not a shocker, pork scrapple on its own has a hard time moving in a restaurant that's clientele is 40 percent vegetarians—although it is not billed as a veghead destination. But if it throws fried pork pieces on a breakfast pizza with eggs, people flock for its slices.

Nearby, Local 44 in West Philadelphia also got into the vegan scrapple action with another take on a mushroom-constructed loaf. One of the popular brunch spot's line cooks developed the recipe years ago, which comprises sautéed shiitakes, puréed button mushrooms, miso and sage. It has all the textural components on lockdown—crispy crunch on the exterior, tender as an oyster on its interior. Grab a fry-like side for four dollars, or if a meat lover is feeling adventurous, slices of the "scrapple" have been used as a breakfast sandwich's bread, with bacon and sausage gravy cushioned between. Local 44 additionally sells non-vegan head cheese scrapple.

For Daniel Hale Zantzinger and his wife, Svetlana, the duo behind Russian Pepper USA, a specialty foods purveyor based in Chester County, Pennsylvania, they are looking to take the "nasty" out of scrapple. (Russian Pepper's debut follows another Chester County producer Long Cove Foods' launch of vegan scrapple, a product that was comically billed with the tagline, "I Can't Believe It's Not Offal.") The pair created a porcine-based, "snout-free" rendition of vegan scrapple crafted with cremini mushrooms from nearby Kennett Square (the so-called Mushroom Capital of the World), organic non-GMO polenta and buckwheat flower. Zantzinger's family roots date back to the region well before the American Revolution, so he's adamant in confessing that they honed in on the flavor of their meat-free scrapple by mimicking Habbersett's taste, making research trips to the Reading Terminal Market and studying Amish cookbooks. Give it a blind taste-test and see for yourself.

Shrimp and Crab Scrapple

In downtown Lancaster, Pennsylvania, chef Tim Carr of Carr's Restaurant, pays tribute to his upbringing of "meat and potatoes." Although his restaurant specializes in inventive New American cuisine, his menu features a "Taste of Lancaster County" section that is comfort-food staples. He's also breathed fresh life into scrapple by concocting a shrimp and crab version of it that flaunts dressings like an orange-maple reduction or sauerkraut braised in local beer, browned butter and rosemary applesauce.

Scrapple Pizza

Frank Maimone, owner of Rustica pizza shop in Philadelphia's trendy Northern Liberties neighborhood, tapped into the scrapple-topped pizza long before Triangle Tavern. It started first as a one-off special on a weekend night in 2014. The presumably one-night-only pie was so popular that he couldn't deny putting it on the menu and making it a permanent offering.

The motto of Maimone's—a self-proclaimed scrapple lover—shop is that it makes pizza you'd want to eat. Given that he's an addict for the porky loaf, it was a no-brainer that he'd venture into chopping scrapple up into bits and sprinkling them on a white pizza dough to create a breakfast-inspired offering with additional ingredients like sunny-side up eggs and a Sriracha drizzle.

The pizza remains popular today crafted with Habbersett exclusively—"there is no other brand."

Scrapple Pie

Take a quick weekend trip to Wards Pastry Shop in Ocean City, New Jersey, and you'll discovered that the eighty-nine-year-old bakery's claim to fame is its best-selling pie—made with scrapple! As the story goes, in 2014, Wards' owner and chief baker Walter Hohman wanted to dream up a new pie flavor that would have novelty potential for his busy season. Hohman, having worked at his family's pie shop since age twelve, has been through the bacon-on-dessert crave, but nothing ever stuck. When his friend Ed Hitzel, a

former food critic, suggested a creating a pie with scrapple, Hohman thought it was crazy enough to work.

The pie in question is started with a basic buttery crust. The baker cuts scrapple into square chunks and prebakes them on a cookie sheet. Once done, the porky hunks are layered into a two-serving crust and loaded with crowd-pleasing streusel. The end result is comparable to mincemeat pie and good enough that he sells a dozen five-inch scrapple pies a day. Be warned: they are sold out by the afternoon.

Scrapple Ice Cream

Over in Philadelphia, at the old-timey Franklin Fountain, it's history-driven ice cream creators were mad enough to whip it up with frozen cream. After the photo of the "Wegmans Fresh Scrapple Ice Cream" pint went viral on Facebook in August 2016, with 6,380 shares, but proved to be a fake, brothers Eric and Ryan Berley decided they'd make it a limited-time reality after a victorious nudge from the online publication *Billy Penn*.

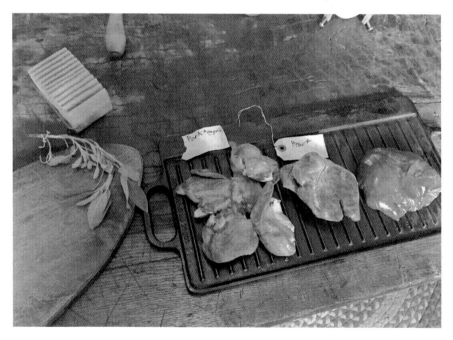

Pig organs and pork "scraps" being used to make scrapple ice cream. *Franklin Fountain.*

Left: Eric Berley, co-owner of Franklin Fountain of Philadelphia, preparing its original scrapple ice cream recipe. *Franklin Fountain.*

Below: Brothers Ryan and Eric Berley preparing a batch of scrapple ice cream for curious Philadelphia customers. *Franklin Fountain.*

A Delectable History

The Berleys opted to follow a recipe that wouldn't have been foreign on American farms in decades' past. What resulted was a savory, chunky ice cream crafted by the combination of milk, heavy cream, buckwheat flour, spices and a heck of a lot of scrapple. Ice cream adventurists were encouraged to enjoy it sweetened by a selection of condiments—tree syrups like maple, butternut and black walnut, apple butter, ketchup—plus corn wafers and corn flakes.

Scrapple Vodka

Now, here is where things take a turn for the road less traveled. In 2013, Painted Stave Distilling opened to the public in a renovated 1948 movie house in Smyrna, Delaware. In their early stages, partners Ron Gomes Jr. and Mike Rasmussen embarked on a "research" road trip to Kentucky to attend a distilling conference.

"One of the conversations we had during that road trip was centered around 'unique spirits' we had heard about, had tried or that were in our collections," recalled Gomes. "That actually got us talking about what spirit could we uniquely create in Delaware and sell in our local environment. Scrapple was probably one of the first things out of our mouths. We asked ourselves, 'could we do that?'"

And they did. "Our overall premise of what we do, like a lot of craft distilleries growing in the country, we are a local grain—as much as possible—and raw material, glass-or-bottle distillery. Scrapple fits right in with local terroir here in Delaware."

While they won't divulge what scrapple they put into their scrapple vodka, Off the Hoof, it is sourced locally, and the spirit's adjunct ingredients include sage, cracked black pepper, cracked nutmeg, bay leaves and apples.

In a sixty-gallon batch, Painted Stave adds ten pounds of scrapple and all the adjunct ingredients and fires up the copper still. "The trick is to still make vodka," Gomes continued. "We make essentially three cuts. Within those three cuts, one of them is what we are going to bottle. The run takes about six hours to get through a batch. Batches end up being pretty big—within the 800- to 900-bottle range. Our largest batch ran just over 1,100 bottles."

The coolest part? Off the Hoof is the distillery's top best seller. It has long legs, too, having made its way to the Netherlands, Hawaii and Seattle.

Off the Hoof Scrapple Flavored Vodka, vodka distilled with local scrapple by Delaware's Painted Stave Distilling. *Painted Stave.*

"During the holidays, I am awfully surprised by the e-mails I get asking where they can buy this product."

If you're curious for a taste, Gomes offers you a primer. "Overwhelmingly, people are surprised with how good it is. The expectation is pretty low, and I think other products like bacon vodka ruined their expectations. But people find it to be a good experience, and people's memories and palate preferences for scrapple tend to be all over the place. The best is when they say, 'you got it, this so reminds me of breakfast.'"

Scrapple Beer

Another off-the-wall thinker, Sam Calagione of Dogfish Head Craft Brewery in Milton, Delaware, introduced a Rapa Scrapple-infused stout in 2014 as a seasonal draft at his Dogfish Head Brewings & Eats in Rehoboth Beach. The beer was a creative collaboration with former Dogfish brewer Ben Potts, who then said it was so well-received it wouldn't be a one-and-

A Delectable History

done novelty. The beer's original launch also came with free slices of scrapple pizza, scrapple tacos and scrapple sliders.

The scrapple beer's mouthfeel was said to strike palates—in a good way! It possessed a smoky meatiness among the standard dark roast characteristics, and once the news of its release dropped, they couldn't make enough of it.

Surprised by its cult-like popularity, fast-forward two years later and the beer has become a permanent release from the brewery called Beer for Breakfast.

The scrapple flavor of the beer is very subtle. It possesses aromatic notes of coffee and smoke, subtle maple and spice.

So why scrapple? The original stout, Chicory Stout, was celebrating its twenty-one-year anniversary, and what better a way to honor the brewery's classic beers than by including a notable Delaware ingredient: scrapple! "To mark the momentous occasion, we have taken a couple decades of experience brewing with culinary goodness and combined our favorite pure, all-natural breakfast ingredients into a beer that we will think you will agree is the most important meal of the day," Calagione relayed.

Plus, Calagione revealed that choosing Rapa Scrapple as the select product for the beer was a no-brainer; it's is the state's (and country's!) largest scrapple producer. Rapa is located miles away from Dogfish's Milton brewery and even produced a special scrapple just for Dogfish

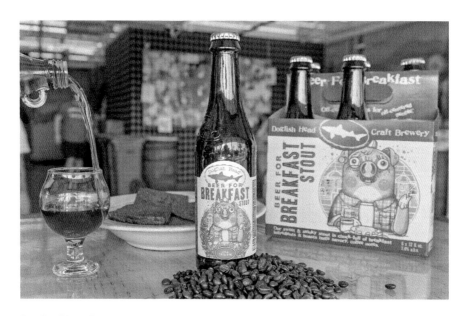

Dogfish Head Beer for Breakfast Stout, a stout brewed with Rapa Scrapple. *Dogfish Head Craft Brewery.*

Head that's a leaner version of its original recipe, so you won't find any oily residue from the meat in your dark beer.

"Working with Sam and the brewers at Dogfish Head was an interesting experience," said Rapa's Donna Seefried. "Sam's vision of translating the distinctive taste of Rapa scrapple into a beer was a unique proposition. Both Dogfish Head and Rapa's production team brainstormed more than a few ideas, and it was decided that a super-lean version of our original recipe would balance nicely with the other ingredients. The end result is a remarkable beer that manages to bring together all the flavors of the quintessential American breakfast."

Have your scrapple and (enjoy) drinking it, too.

Scrapple Art and Greeting Cards

Mike Geno, a popular fine artist from Philadelphia who specializes in realistic paintings of culinary objects, garnered press and lots of foodie attention from his local food art series. Within the series that included paintings of soft pretzels, cheesesteaks, Butterscotch Krimpets and hoagies, there was an oil painting of two slices of scrapple with all the crunched-edge details. He explained that since scrapple isn't the most attractive breakfast stable, he was left with little choice but to reference Rothko's abstract color field paintings. "I feel this gives one the versatile art that can be both abstract and specifically representational at once," he wrote. "Love it or hate it, scrapple is considered a local treat. Regardless, it's definitely part of Philly's local food identity." Satisfy your need for a sneak peek by visiting mikegeno.com.

Half and a Third, a graphic design boutique in Philadelphia, Pennsylvania, creates scrapple-influenced Valentine's Day cards. *Half and a Third.*

A Delectable History

In February 2017, the woodworking and graphic design boutique of Ian Stafford and Katey Mangels, Half and a Third, in Philadelphia, Pennsylvania, unveiled the latest line of stationery to mushy card-givers. Designed by Mangels, the card reads, "You're the ketchup to my scrapple," accompanying a font similar to Heinz and a brick of gray-hued delight. If you ever wanted to scribble down how you feel toward a ketchup-smothering scrapple lover, now is your time to shine. Available at halfandathird.com.

Scrapple Songs

Then came intangible objects. Sure, the eccentric relative of the family of breakfast foods would garnered its fair share of attention in the pop-culture spotlight.

One of the most memorable of moments for the meat that so many people love, yet just as many hate, dropped in 1947 when Charlie Parker penned a bebop composition, "Scrapple from the Apple." The song, which is now largely considered a classic for the bebop repertoire, earned a reputation of its own and respectable interpretations on albums by Jim Hall, Dave McKenna, Sonny Stitt and Phil Woods, among many others.

The lyrics were subtle, discussing Parker hitting the road to "see the Apple," and while he was there, he planned to "I'm gonna cut me off some scrapple, Gonna cut that Apple right down to the core."

No song was as special or more aggressively blatant as Robin Remailly's (of Holy Modal Rounders) composition, "Happy Scrapple Daddy Polka." Released in 1971, the American folk musician penned a two-minute, seventeen-second psychedelic wonder that was thoroughly celebrated and was queasily carnivorous.

Lyrics bumbled out expressing such statements as:

> *I'm your happy scrapple daddy from the Pennsylvania farm.*
> *I'm your happy scrapple Daddy with all them piggish charms.*
> *Raised up in the hill, my taste is most refined.*
> *I'm your happy scrapple daddy bringing greasy good times.*
> ...
> *I hope you like your pig feet, I really hope you do.*
> *Cause I love to see a chin just a-drippin' with goo.*
> *I start with the feet, I eat the whole hog*

Pennsylvania Scrapple

The chorus swaggered with:

Pork liver, lambies tongues, vienna sausage—awe, save me some. Chitlins, ah them chitlins, calf brains and rare steaks, linguisa and kielbasa eat your sister by mistake. / Oh, what that meat eatin' gonna make you wanna do.

Robbie Fulks, an American alternative country singer-songwriter, took the more traditional approach with "The Scrapple Song." With Fulks born in York, Pennsylvania, the 1996 hit illustrated that the musician himself knew a thing or two about the iconic sizzling slab.

He threw in the country music spotlight such lyrics as:

Hey call it Scrapple! Scrapple
Cornmeal steamed, and hogmeat dappled
Set by the window till it's cold and hard
Sliced up thick and fried in lard
Hey what's that swimmin' in the big red pan
That's kickin' up all this mania
It's scrapple, scrapple, the pride of Pennsylvania

Variations and scrapple add-ins cushioned the song as it carried on, including more tongue-in-cheek, tried-and-true lyrics:

Hearty as a t-bone, slippery as a tadpole
Any old part of the hog will do
Neck, and the nipples, and the toenails too.

Didn't bring a plate then fork you a hatful
Workin' in the field till the sun goes down
Grandma's whipped up twenty-five pounds

The most comical of all existing scrapple songs is that an underground album, *Scrapple Rocks*, dedicated to the "world's greatest mystery meat," exists, as presented by the Independent Global Citizen. Manufactured in Camden, New Jersey, fourteen musicians lent their own scrapple-inspired tune to the celebrate the piggy goodness. And if you are thinking this is all a joke, you can find the album in its entirety on YouTube.

A Delectable History

You'll be delighted to uncover that you can now enjoy your favorite breakfast meat while listening to meal-appropriate songs like "How Do You Like Your Scrapple" by The Butchers, "Scrapple Babe" by Oinkland Mountain Boys" and "Funky Spiced Meat" by Cardiac All-Stars. Perhaps these are not real performing artists, but this parody album and the effort that went into its production showcases one of the most extreme grand gestures of scrapple appreciation to date (and my favorite).

Scrapple Gets Political

In the early days of World War II, the National Livestock and Meat Board's Department of Home Economics published *Meat in the Meal for Health Defense*, a homemaker-friendly guide to making the most of cheaper, less popular cuts. Formulated under the nutritional parameters set by the federal government's National Nutrition Program, which operated by the advertising campaign slogan, "Food will build a new America!," it featured recipes to encourage home cooks to think twice about non-prime cuts and augment cheaper ingredients to extend meals.

Within the pages of practical recipes, it produced of range of one-hit wonders, like Kidney and Bacon Loaf ("Famous Food Affinities in New Role"), Beef and Kidney Stew ("A Good Stew Is No Hardship") and Veal Hearts with Noodles ("A Thrifty Dish with Flavor Plus"). In my eyes, the star—and most appropriate—recipe of the collection was its Defense Scrapple ("An Old American Favorite Up-to-Date").

The recipe (republished here in the appendix) makes use of common scrapple ingredients that one would have in the household—pork, cornmeal, egg, crackers—and adds in some simple health-conscious add-ons, such as celery leaves and parsley.

Defense Scrapple and its hopeful sister recipes may have not built a better America in the '50s. But during the 2016 political race between Donald Trump and Hillary Clinton, several Philadelphia-based activists used scrapple itself to drive home their political views during protests. Since Pennsylvania is, in fact, the birthplace of the homely gray brick, pedal-pushing citizens threw up signs spouting, "Philadelphia isn't afraid—we invented scrapple!"

And that, my friends, is true. It takes a hungry, utilitarian-like army to build an undying cultural presence for such a misunderstood meat.

Appendix I
GET IN THE KITCHEN

Scrapple Recipes to Spark a Meaty Love Affair

After combing through page after page of scrapple knowledge, you didn't expect me to leave you without scrapple-making inspiration, did you? Discover my favorite scrapple recipes in this section, ranging from how you can make your own batch from scratch to classics—simple pan-fried slabs sandwiched in white bread—and inventive creations that'll inspire you to have endless culinary fun with your porky loaves.

SCRAPPLE RECIPE
Courtesy of Adam Diltz, chef-owner Elwood BYOB, Philadelphia

INGREDIENTS
2 pounds fresh pork
½ pound pork liver
3 quarts pork stock (made from the pork cooking process)
¼ cup chopped sage
¼ cup salt
¼ cup black pepper
1 pound cornmeal
12 ounces buckwheat flour

Appendix I

Classic white bread sandwich with a slice of scrapple. *Amy Strauss.*

Method

Scrapple is a long process, so plan on starting it and finishing it the next day.

First, put your pork and liver in a large pot and cover it with water. Bring it up to a boil and simmer it for 3–4 hours until the meat is falling off the bone. Strain the broth and let the meat cool down until you can shred it with your hands. Pick all the meat off the bones like you are making pulled pork. If you have a grinder, pass the meat and liver through the plate with the widest holes. If you don't have a grinder, just chop the meat and liver into small pieces.

Take 3 quarts of the pork stock that you made from cooking the meat and bring it up to a boil. Stir in the sage, salt and black pepper. Continue whisking the broth while pouring the grains in a steady stream. Let it come to a boil while continually stirring.

Add the meats and continue stirring until it's a homogenous mass. It will get really thick and will be really hot, so be careful.

Pour into loaf pans and let cool overnight. The next day, turn out the scrapple and cut off about ¼-inch slices. Heat up a cast-iron pan or thick-bottomed sauté pan. Add a few tablespoons of oil, and

Appendix I

when it is very hot, place your scrapple slice in. When it's dark and has formed a nice crust, flip it over. Sear this side, transfer to a plate and enjoy. Serve with your favorite breakfast items—eggs, pancakes and so on. The best sauces to eat with scrapple are a little acidic and contrast with the meatiness of the dish. Hot sauces are really good, as are fruit butters.

Classic Pan-Fried Scrapple Sandwiches

Ingredients
1 teaspoon canola oil
8 ½-inch-thick slices scrapple
8 slices white bread
maple syrup (or your condiment of choice)

Method
Heat a cast-iron skillet over medium-high heat. Add oil. Once the oil begins to quietly sizzle, add the scrapple slices. Sear each side until crispy and dark brown, about 3–5 minutes each. Once complete, transfer to plate lined with paper towels to absorb oil from pan.

Place two ½-inch slabs of scrapple onto a slice of bread, drizzle with syrup or condiment of choice (pepper jelly, ketchup, mustard) and close the sandwich. Repeat with the remaining ingredients. Makes 4 sandwiches.

Philly Breakfast Pizza
Adaption of Godshall's Recipe

Ingredients
2 cups tater tots
1 pound scrapple, cubed
½ pound pizza dough or premade 12-inch pizza crust
1 cup sharp provolone, shredded
1 cup part skim mozzarella, shredded
salt (to taste)
adobo (to taste)

Appendix I

Method

Bake tots in oven at 350 degrees while browning scrapple in skillet with plenty of nonstick spray. Unroll and/or press out dough to 12-inch or 14-inch pizza pan. Remove lightly browned tots (approximately 12 minutes). Scatter scrapple slices, tots, provolone shreds and mozzarella shreds. Bake at 390 degrees (approximately 10–12 minutes) until cheese is golden. Add salt and/or adobo to taste and serve warm and delightfully gooey.

Delaware Scrapple Dip
Courtesy of McCormick

Scrapple finds a home in this creamy game day dip. Mixed with layers of cream cheese, cheddar cheese and a package of Old Bay® *Crab Cake Classic*® *Mix, you won't be able to resist this party-time crowd pleaser. Serve with assorted crackers or sliced French bread.*

Ingredients
1 tablespoon oil
½ pound (8 ounces) scrapple, sliced ¼ inch thick
2 packages (8 ounces each) whipped cream cheese
½ cup white cheddar cheese, finely shredded
1 package Old Bay® Crab Cake Classic® Mix

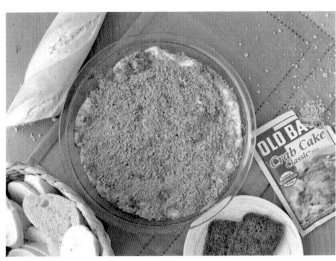

Delaware Scrapple Dip. *McCormick.*

Appendix I

Method
Preheat oven to 350 degrees. Heat oil in large skillet on medium-high heat. Add scrapple; cook 3 to 4 minutes or until browned, turning occasionally. Remove from skillet. Coarsely chop scrapple and place in large bowl. Stir in cream cheese and shredded cheese. Spread in 9-inch glass pie plate. Sprinkle with crab cake mix. Bake 30 minutes or until hot and bubbly. Serve with assorted crackers or sliced French bread. Makes 2 cups or 16 (2-tablespoon) servings.

The Scrappletini
Courtesy of Painted Stave

Located in Smyrna, Delaware, the small-batch distillery recommends its scrapple-flavored vodka for cocktails that highlight its unique flavor, such as a Bloody Mary or a simple, semi-sweet martini recipe like that featured here.

Ingredients
1 ½ ounces Off the Hoof scrapple vodka
¾–1 ounce dry vermouth (not crazy expensive)
sage leaf (optional)

Method
Stir ingredients on the rocks and pour into a martini glass, served up. Enjoy as is or garnished with a sage leaf.

Scrapple Dotties
Courtesy of Rapa Scrapple

Ingredients
1 package Rapa Original Scrapple
1 package bacon

Method
Cut Rapa Original Scrapple into ½-inch cubes. Roll each cube in half a strip of bacon. Fasten with a toothpick. Broil until crisp—about 6 inches away from heat. Serve on toast quarters.

Appendix I

Defense Scrapple

(From *Meat in the Meal for Health Defense*, 1942)

Ingredients
1 pound lean pork
1 quart water
1 ½ cups cornmeal
1 teaspoon salt
1 tablespoon celery leaves, minced
¼ cup minced parsley
½ teaspoon sage
1 egg, beaten
cracker crumbs
lard for frying

Method
Simmer meat until tender enough to slip from bones. Remove meat, cool and grind. Measure remaining liquid and add enough water to make a quart. Bring broth to a boil. Add cornmeal slowly, stirring constantly. Add seasonings and meat. Pour mixture into a loaf pan and chill until well set. Slice, dip in beaten egg and then in cracker crumbs. Fry in lard until the slices are crisp and nicely browned.

Appendix II
YOUR PHILADELPHIA SCRAPPLE GUIDE BOOK

Embark on an epic scrapple-tasting road trip by hitting my list of both classic and unconventional restaurants, diners, delis and market stops.

PHILADELPHIA & PHILADELPHIA SUBURB RESTAURANTS

COFFEE STATION, 7 Kedron Avenue, Morton (Tip: home of the Scrapple Fries)
FRANCONIA HERITAGE RESTAURANT, 508 Harleysville Pike, Souderton
GREEN EGGS CAFÉ, multiple locations throughout Philadelphia
HONEY'S SIT 'N EAT, 800 North Fourth Street; 2101 South Street, Philadelphia
JERRY'S BAR, 129 West Laurel Street, Philadelphia's Northern Liberties neighborhood
JOHNNY BRENDA'S, 1201 Frankford Avenue, Philadelphia's Fishtown neighborhood (Tip: deep-fried scrapple balls of joy)
KENSINGTON QUARTERS, 1310 Frankford Avenue, Philadelphia's Fishtown neighborhood (Tip: it makes its own scrapple for brunch and serves it as a side or as Scrapple French Toast)
RUSTICA, 903 North Second Street, Philadelphia's Northern Liberties neighborhood (Tip: scrapple pizza at any time of the day!)

Appendix II

Sam's Morning Glory Diner, 735 South Tenth Street, Philadelphia's Bella Vista neighborhood

Shorty's Sunflower Café, 1494 North Charlotte Street, Pottstown (Tip: Flying Dutchman breakfast special)

Station Taproom, 207 West Lancaster Avenue, Downingtown (Tip: scrapple eggs Benedict)

Zook's BBQ at Newtown Farmers' Market, 2150 South Eagle Road, Newtown (Tip: killer scrapple, egg and cheese sandwiches)

Philadelphia Diners

M&M Restaurant, 2736 East Allegheny Avenue

Melrose Diner, 1501 Snyder Avenue

Silk City Diner, 435 Spring Garden Street

Spring Garden Diner, 400 Spring Garden Street (Tip: you can score a scrapple and egg sandwich for only $2.90!)

Sulimay's, 632 East Girard Avenue (Tip: the Eggs Bensington or the Pig Heaven omelet are can't-miss scrapple dishes)

Reading Terminal Market (51 North Twelfth Street, Philadelphia, Pennsylvania)

Down Home Diner (Tip: one of Philly's best scrapple dishes—served with poached eggs)

Dutch Eating Place (Tip: one of the most traditional Pennsylvania Dutch breakfasts you'll find in Philadelphia)

Hatville Deli (Tip: sells the iconic "Frank's Scrapple")

Smucker's Quality Meats & Grill (Tip: first market vendor to sell scrapple breakfast sandwiches—a must try; there's a reason it has stuck around)

Appendix II

Berks and Lancaster County Butchers, Country Diners and Restaurants

Dietrich's Meats & Country Store, 660 Old U.S. 22, Lenhartsville (Tip: the ultimate Pennsylvania Dutch meat market run by butchering goddess Verna)
Groff's Meats, 33 North Market Street, Elizabethtown, Pennsylvania
Martin's Custom Butchering, 405 Reidenbach Road, New Holland, Pennsylvania
Shady Maple Smorgasbord, 129 Toddy Drive, East Earl, Pennsylvania (Tip: real-deal Pennsylvania Dutch buffet with endless scrapple and next-door grocery store for you to take some for the road)
Stohler's Meat Market, 1643 Heidelberg Avenue, Schaefferstown, Pennsylvania
Stoltzfus Meats, 14 Center Street, Intercourse, Pennsylvania
Zimmerman's Custom Butcher, 420 Royer Road, Lititz, Pennsylvania

Delaware Destinations

Dogfish Head Craft Brewery, 6 Village Center Boulevard, Milton, Delaware (Tip: scrapple beer)
Frankford Family Diner, 34067 Dupont Boulevard, Frankford, Delaware (Tip: Delaware omelet)
Haas Family Butcher Shop, 3997 Hazlettville Road, Dover, Delaware
La Fia Market Bistro, 421 North Market Street, Wilmington, Delaware
Painted Stave, 106 West Commerce Street, Smyrna, Delaware (Tip: scrapple vodka)
Papa Grande's, 210 Second Street, Rehoboth Beach, Delaware (Tip: goat scrapple in tacos)
Rapa Scrapple, 103 South Railroad Avenue, Bridgeville, Delaware (Tip: the President of the "Scrapple Capital of the World")
Wilson's General Store, 24739 Springfield Road, Georgetown, Delaware (Tip: scrapple, egg and cheese sandwiches)

BIBLIOGRAPHY

Breslow, Jan. "Relax! You Don't Have to Scrap Scrapple." *New York Times*, October 9, 1996. http://www.nytimes.com/1996/10/14/opinion/l-relax-you-don-t-have-to-scrap-scrapple-763276.html.

Brody, Joshua Raoul. "Happy Scrapple Daddy." *Gastronomica: The Journal of Critical Food Studies* 1, no. 1 (2001): 122.

Bustard, Arthur C. "Hatfield Quality Meats, Inc.: Quality, Integrity & Success for 100 Years." Graduate thesis, Lehigh University, May 1995.

Cohen, Jason. "Everything You Need to Know About Scrapple." *Serious Eats*, September 1, 2015. http://www.eater.com/2015/9/1/9211867/scrapple-goetta-livermush-what-is-it.

Ellis, Susan J. "Traditional Food on the Commercial Market: The History of Pennsylvania Scrapple." *Pennsylvania Folklife* 22, no. 3 (Spring 1973): 10–21.

Giangreco, Leigh. "Scrapple Rooted in Delaware Valley." *DelmarvaNow*, October 11, 2014. http://www.delmarvanow.com/story/news/local/delaware/2014/10/11/brief-history-scrapple/17133711.

Hedbor, Lars D.H. "A Pennsylvania Dutch Meal." *Journal of the American Revolution*, June 14, 2013. https://allthingsliberty.com/2013/06/a-pennsylvania-dutch-meal.

Hiller, Elizabeth O. *The Corn Cook Book*. N.p.: P.F. Volland Company, 1918.

Hillinger, Charles. "Scrapple: The Way to a Philadelphian's Heart." *Los Angeles Times*, September 24, 1989. http://articles.latimes.com/1989-09-24/news/vw-247_1_scrapple-years.

BIBLIOGRAPHY

Jalowitz, Alan. "Scrapple: Pennsylvania's 'Other' Meatloaf." Pennsylvania Center for the Book, spring 2013. http://pabook2.libraries.psu.edu/palitmap/Scrapple.html.

Jones, Paul. "Book Review: Philadelphia Scrapple. Whimsical Bits Anent Eccentrics & the City's Oddities. By Several Anonymous Philadelphians." *Pennsylvania Magazine of History and Biography* 81, no. 3 (1957): 337–38.

Kerrigan, Lynn. "Scrapple: Pork Mush—The Pennsylvania Treat." *Culinary Sleuth*, 1998. http://www.foodwine.com/food/sleuth/0998/scrapple.html.

Kummer, Corby. "Sausages, Souse, and Shandybookers." *Atlantic Monthly* (July/August 2001): 143–47.

Kurath, Hans. "German Relics in Pennsylvania English." *Monatshefte Für Deutschen Unterricht* 37, nos. 4–5 (1945): 96–102.

Land, Leslie. "Fare of the Country: Sampling Scrapple at the Source." *New York Times*, April 5, 1987. http://www.nytimes.com/1987/04/05/travel/fare-of-the-country-samplig-scrapple-at-the-source.html.

Myers, K.P. "Why We Eat What We Eat." In *Hedonic Eating: How the Pleasurable Aspects of Food Can Affect Our Brains and Behavior*. New York: Oxford University Press, 2015.

Ozersky, Josh. "Scrapple Is One of the Crucial American Meats." *GQ Magazine* (2014).

Pearson, A.M., and T.A. Gillett. "Sausages." In *Processed Meats*. N.p.: Springer US, 1996.

Perl, Lila. *Red-Flannel Hash and Shoo-Fly Pie*. Cleveland, OH: World Publishing Company, 1965.

Rhodes, Jesse. "Scrapple: The Meatloaf of the Morning." *Smithsonian Magazine* (November 8, 2011). http://www.smithsonianmag.com/arts-culture/scrapple-the-meatloaf-of-the-morning.

Rozzo, Mark. "Pennsylvania Dutch Treat." *Bon Appétit* (August 2010): 91–97.

Schneider, Robert I. "Country Butcher: An Interview with Newton Bachman." *Pennsylvania Folklife* 20, no. 4 (Summer 1971): 21–25.

Shelling, Richard I. *Pennsylvania History: A Journal of Mid-Atlantic Studies* 25, no. 3 (1958): 328–30.

Urgo, Jacqueline L. "Scrapple Pie? No Kidding. It Outsells Apple in Ocean City." *Philadelphia Inquirer*, August 27, 2016. http://www.philly.com/philly/living/travel/shoreguide/20160827_Scrapple_pie__No_kidding__It_outsells_apple_in_Ocean_City.html.

Vogt, Frederick A. "Process of Canning Scrapple." U.S. Patent 1,035,502, issued August 13, 1912. U.S. Patent Office, Alexandria, Virginia.

Bibliography

Wang, Chichi. "The Nasty Bits: Scrapple." Serious Eats, March 2012. http://www.seriouseats.com/2012/03/the-nasty-bits-scrapple.html.

Wood, Robert. "The Historian—Scrapple: 'Flower of Flavors.'" *Berks Mont News*, January 4, 2016. http://www.berksmontnews.com/article/BM/20160104/NEWS/160109979.

Zagat. "What Is Scrapple? Food Tripping with Molly, Episode 6." YouTube video, 8:44. Posted October 6, 2015. https://www.youtube.com/watch?v=WRbm_X4G0BI.

INDEX

A

Adam, George 52
Adams, Ralph and Paul 36
Alderfer Natural Wood Smoked Meats 39
Apple Scrapple Festival 45
Arnold's Meats 42

B

Bachman, Newton 51
Beer for Breakfast 105
Beissel, David 26
Berley, Eric and Ryan 101
Bernard S. Pincus Company 43
Bieber, George 89
Bingham, Dr. David Rittenhouse 23
Bizarre Foods with Andrew Zimmern 54
Breakfast Bomb 91
Breslow, Jan 19
Burk's Sausage Company 42

C

Calagione, Sam 104, 105
Carr's Restaurant 100
Castle Valley Mill 75
Chopped 20
Clemens, John C. 37

D

Darlington, Amos 43
Defense Scrapple 116
Delaware Scrapple Dip 114
Dietrich's Meats and Country Store 63
Dietrich, Verna 63
Dietz, Gottlieb 41
Dietz & Watson 41
Diltz, Adam 94, 111
Dogfish Head Craft Brewery 104
Domestic Cookery 26
Down Home Diner 83
Dutch Eating Place 88

E

Eni, Louis 41, 42
Esh, Jaden 87
Esh, Samuel 68, 87

INDEX

F

Fields, W.C. 10
Finkel, Kenneth 22, 32
Flay, Bobby 54, 85
Florida Avenue Grill 93
Flying Dutchman, the 89
Food Nation 54
Franklin Fountain 101
Frank's Country Scrapple 68
Fulks, Robbie 108

G

Geno, Mike 106
Gerard, Adam 78, 92
Godshall's 40
Gomes, Ron, Jr. 103, 104
Goschenhoppen Folk Festival 53
Goschenhoppen Historians 53
"Great Scrapple Correspondence of 1872, the" 18
Groff's Meats 69

H

Habbersett, Ed 31
Habbersett, Isaac S. 34
Habbersett Scrapple 15, 28, 31, 33
Haines Pork Shop 40
Haldeman Mills 66
Half and a Third 107
"Happy Scrapple Daddy Polka" 107
Hatfield Packaging Company 37
Hatfield Quality Meats 28, 37
Hatville Deli 68
Heirloom 98
Hogg, Robert T. 30
Hohman, Walter 100
Honey's Sit 'N Eat 90

I

Independent Global Citizen 108

J

Jerry's Bar 91
Johnny Brenda's 94
Jones Dairy Farm 35, 36

K

Kennedy, Tom 34
Kensington Quarters 72
Kunzler & Company Inc. 41
Kutztown Folk Festival 51, 64

L

La Fia 98
Lambert, Marcus Bachman 24
Lancaster Okonomiyaki 96
Lea, Elizabeth Ellicott 26
Leidy, Jacob 40
Leidy's 39
Levitsky, Sarah 47
Little Miss Apple Scrapple 46
Local 44 99
Long Cove Foods 99
Lower Rhineland 22

M

Maimone, Frank 100
Martin's Custom Butchering 69
McDavid, Jack 84
McDavid, Jason 83
McKinney, Mark 98
Meat Hook, the 69
Meat in the Meal for Health Defense 109
Menapace, Damon 72
Mission Taqueria 94
Moker, Molly 20
Mountis, Cus 90

N

Nead, Dr. D.W. 27
Neptune Diner 90

INDEX

New Castle Farmers' Market 65
Newman, William 42

O

Off the Hoof 103, 115
Orkin, Ivan 95
Oscar Mayer Company 44
Ozersky, Josh 70

P

Painted Stave Distilling 103
Pan-Fried Scrapple Sandwiches 113
panhas 27
Papa Grande's 98
Parker, Charlie 107
Pennsylvania Society of New York 30
Philadelphia Scrapple 25
Philly Breakfast Pizza 113
Pincus, Bernard S. 43
Pleasant Valley Packing Company 37

R

Ramen, Ivan 96
Rapa Scrapple 28, 45
Reading Terminal Market 47, 68, 88
Renninger's Farmers' Market 65
Russian Pepper USA 99
Rustica 100

S

Schwenk, Barry 55, 97
Schwenk, Terry 62
S. Clyde Weaver 69
Scrapple Dotties 115
ScrappleFest 47
Scrapple from the Apple 107
Scrapple Paradise 23
Scrapple Rocks 108
"Scrapple Song, The" 108
Scrappletini 115
Shorty's Sunflower Café 89

Sietsema, Robert 96
Smucker, Moses 88
Smucker's Quality Meats & Grill 88
Stohler's Meat Market 69
Stoltzfus, Amos 65
Stoltzfus Meats 65
Stoltzfus, Myron 65
Strode, Marshall and Francis 43
Strode's Mill 31, 43
Strode's Pork Products 43
Sulimay's 91

T

Triangle Tavern 98

V

Vogt, Frederick A. 30
Vogt's 44

W

Wards Pastry Shop 100
Washington, George 10
Weaver, William Woys 31
Werner, Jim 54, 92, 93
West Coast Scrapple 49
What's Scrapple? blog 78

Y

Yoder's Country Market 31

Z

Zagat 20
Zantzinger, Daniel Hale 99
Zimmerman's Butcher Shop 69

ABOUT THE AUTHOR

Amy Strauss is a food and drink writer and editor living in Philadelphia. With a knack for uncovering the beauty in all things delicious, she takes to the streets of the City of Brotherly Love and beyond to discover its stories and relay them to you on a silver platter. With a decade of publishing experience in print and online publications for outlets like *Philly Beer Scene*, *Edible Philly*, the *Spirit News*, the Town Dish, *Main Line Today* magazine, *Spoonful* magazine, Southwest Airlines, OpenTable, *BlackBook* and *Philadelphia City Paper*, among others, she's hungry, she's eager and she loves to have her cake (and eat it, too). Beyond food and drink journalism, Amy is experienced with building creative content for brands like Campbell Soup Company, Victory Brewing Company, Iron Hill Brewery & Restaurant, Garces Group, Airgas and more. She's obsessed with her Pennsylvania Dutch heritage, slices of funfetti cake and not giving up hope for the Philadelphia 76ers. Follow her ongoing culinary pursuits on Instagram at @amystrauss or online at www.amystrauss.com.